SOME MODERN
SCULPTORS

DESCRIPTION OF FRONTISPIECE

The wings of this guardian angel are rendered strictly in the Byzantine convention. The face is one of the most beautiful that Meštrović has achieved.

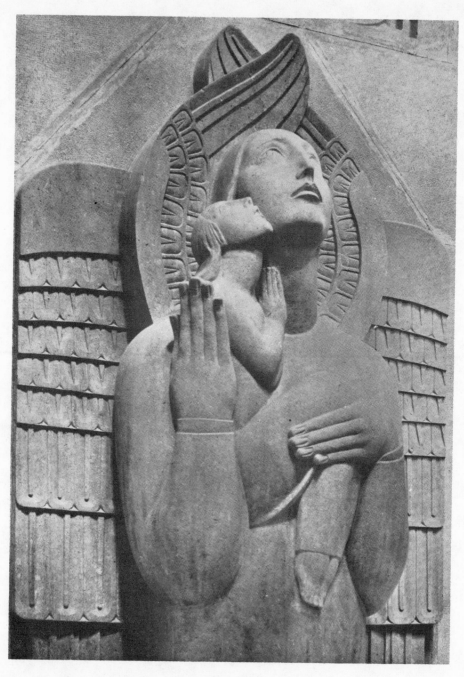

ANGEL FROM THE CHAPEL AT CAVTAT

*by Meštrović*

# SOME MODERN SCULPTORS

*By* STANLEY CASSON

*Essay Index Reprint Series*

BOOKS FOR LIBRARIES PRESS, INC.
FREEPORT, NEW YORK

First Published 1928
Reprinted 1967

LIBRARY OF CONGRESS CATALOG NUMBER:
67-28746

PRINTED IN THE UNITED STATES OF AMERICA

To attempt to survey the whole of modern sculpture in the limits of a small volume would be impossible. I have selected what I take to be some of the most important sculptors and discussed the most interesting tendencies of modern sculpture. Many fields I have left untouched; the work of modern German and Austrian sculptors is of deep interest, but seems to me for the most part to be dependent upon the work of artists discussed in this book. The work of Archipenko, Zadkine, and others of the 'inorganic school' is often of great charm and beauty, but it falls outside the main development of sculpture and deserves a special study which I have not been able to give it here. The work of Dobson is of high value and interest but demands a fuller treatment than my space allows.

My constant reference to ancient Greek sculpture may seem to some to be tedious and tiresome. I indulge this weakness simply because in ancient Greece, and nowhere else to the same degree, sculpture in stone was an integral part of the artistic life of the people and never a mere artistic luxury. We must, in consequence, refer to Greece for information more than to other lands.

The only justification of this book is that a growing interest in sculpture and a growing activity of sculptors may call for a brief survey of what has been done in recent years.

Among the many kindnesses that I have to acknowledge in the preparation of this work my principal is to Mme. Banaz, who has allowed me to reproduce not only the

portrait of herself by Meštrović, but also has given me full access to her photographs of the Monument at Cavtat, which was erected by members of her family.

To Mr. F. M. S. Winand I am deeply grateful for the loan of photographs of the works of Rosandić and for much help in other ways, and to Mr. Eric Gill for permission to use photographs of his work. The admirable photograph of the Langford Rood is the work of Mr. Kenneth Hare, who was kind enough to take it at my suggestion.

To the Leicester Galleries I am indebted for permission to use a photograph of Gaudier's 'Fawn', and to Mr. Propert of the Claridge Gallery for much useful information.

The Clarendon Press have undertaken the publication with a generosity which I have already learned to appreciate on other occasions.

<div align="right">S. C.</div>

# CONTENTS

## LIST OF ILLUSTRATIONS

## ONE

### THE PRESENT STATE OF MODERN SCULPTURE

#### *With some Comments on Methods and Aims*

A STUDY of modern sculpture is, of necessity, a study of certain individuals and their aims rather than of schools or styles of art. Sculpture in modern times is not a lucrative profession and those who pursue it tend to be artists who find in stone and in three dimensions the best expression of their beliefs and emotions, and who have force of character sufficient to prevent them from being deterred by poverty from the use of so unpromising a medium. There is no room for experimenters or dilettanti for two reasons: one the expense of stone as a material, the other the costliness of failure and the uncertainty of good work being rewarded. After all, in ancient Greece or medieval Europe there was a large and steady demand for sculpture. In Greece the number of private dedications at sanctuaries was enormous, and the number of stone buildings which called for sculptural decoration was about 80 per cent. of all the stone public buildings that were built. In medieval Europe cathedrals, churches, and tombs called for an infinitude of sculptures. Guilds and schools, masters and their pupils, throve in a trade which was lucrative. It is true to say that, at any rate in Greece, no single work of art was ever cut merely as a work of art, nor is there any phrase in Greek which can be translated as 'a work of art'. Each statue was a dedication, or a cult image, or a part of the adornment of a building itself, or of a building that served a purpose.

1

There was no such thing as the statue that was cut to stay in a studio or gallery and that had no destination. The 'work of art' as such did not exist in antiquity, except in painting and in some of the minor arts. The sculptors were busy men who never had to cajole a public into admiration of their work. They supplied needs rather than created luxuries. The ancient Greek could not imagine a statue which had no *destination*. Not that art was in any sense utilitarian: it was functional. The artist served people who needed him. House-adornment or art galleries were unknown until late Greek and Roman times, when commercial millionaires were invented. The artist was the member of an art service, rather than an individual seeking for fame. He had a position tantamount to that of a public servant.

This distinction between the ancient sculptor and the modern is important because it throws some light on the conditions under which the artist worked. There was no strain, no hardship for the ancient, while for the modern there is no certainty of success and no steady demand for his work. This largely explains why eccentricity is so seldom a feature of ancient art and why a general community of style within a given geographical area is not found in modern. Greek sculptors built upon a basis firmly founded by their predecessors. Pheidias was a logical development from a blend of Attic and Peloponnesian styles; Lysippos had learned all the lessons of Polycleitos and advanced beyond him. The Hellenistic artists, with less invention, made a selection from the repertoire of their predecessors and produced an eclectic art. But to-day there is little continuity. The sculptors of the twelfth, thirteenth,

and fourteenth centuries in Italy, France, and Germany led but imperceptibly towards the Renaissance. Between Renaissance and Baroque is a gulf not easily bridged. In the eighteenth and early nineteenth centuries Flaxman, Canova and the rest represent an independent searching of antiquity and a false interpretation of it. They knew too little and had too little of the good work of antiquity before their eyes to succeed. Their work has no sort of inspiration and, in its eclecticism, represents Europe's Hellenistic Age. But in Rodin, and perhaps in Barye—though here less consciously—we see a violent attempt to get away from the clinging shrouds of a dead art. Just as Lysippos, seeing in the limited poses of Polycleitos a hindrance to future development and a line of growth that in hands less gifted than those of Polycleitos might lead to sterility, went straight to 'nature' and, as he said, was 'a pupil of no master, but saw men as they were', so Rodin started at the same point and with the same ideas. But, unlike Lysippos, he had few to guide him from preceding generations. With Rodin modern sculpture follows again the line of development of the ancient, and the 'post-Rodin' manner is exactly parallel to the schools founded by Praxiteles and Scopas. Maillol, Bourdelle, Despiau, and Bernard are all derivative from Rodin; Dobson indirectly and some recent German sculptors like Hoetger are also derivative. But the analogy with antiquity or with the Middle Ages fails in one respect. Behind Rodin and his school there was no body of commercial stone-workers, hardly deserving the name of sculptors, such as those who carved the countless funeral and dedicatory monuments of fourth-century Greece or who

3

carved the figures on the façades of hundreds of medieval churches, or on the lovely tombs of the Renaissance. In the seventeenth century the masters had vanished and left these men alone, inventive, admirable, and conscientious, but not gifted artists. In each of these periods the smaller fry were wholly dependent upon the great sculptors of their day. The smaller men attempted nothing on the grand scale and they achieved nothing beyond the brilliantly mediocre. But they served a world that wanted them and they kept alive a steady activity from which at intervals could sprout and flourish the latent genius that was never far from the surface. The hack-work of fourth-century Greece and of the Middle Ages was the raw material of a new generation of sculptors. Not until the age of Baroque in Europe did this raw material fail to produce great men.

To-day there is no such background of fertile mediocrity from which the artists of the future may be drawn. There has been no real demand for sculpture in a minor way for decorative elements in houses and public buildings, for monuments to the dead, and for churches for a very long time. In England the demand for architectural sculpture died out soon after the Renaissance. Our Tudor tombs are among our last sculptures of this kind. England had no period of Baroque worth the name compared with Spain, Italy, and Austria. The eighteenth century saw in all countries a decline almost to zero in the demand for good decorative or dedicatory sculpture. The Louis XIV house or the Georgian country mansion dispensed with almost all sculptural additions save floral design or incidental cherubs. Public sculptures were very rare indeed.

The Industrial Age rendered sculpture superfluous and undesirable, and monuments of the mid-Victorian Age like the Albert Memorial served but to dot the i's and cross the t's of its death sentence, by emphasizing the divorce of sculpture from architecture. Victorian architecture was almost Mohammedan in its expulsion of the human form from decoration and its devout adoration of pure pattern. Statues were segregated in bunches, as in the Albert Memorial, or marooned in lonely squares like lepers, while the Natural History Museum and the Albert Hall revelled in the intricacies of floralism and formal design. It is no mere coincidence that Abdul Hamid built for himself in Constantinople one of the most perfect examples—and in its way a very fine building—of Victorian architecture in Yildiz Kiosk, or that Turkish mosques like that known as Valide Djami[1] were built in the Victorian Gothic style. The Mohammedanism of the Victorian Age had found its spiritual home, and you will find no better example of Victorian art in London than in Stamboul.

Into this arid land Rodin came like a magician ready to create new forms in sculpture which, true to the spirit of the age, scorned architecture, but which, unlike the rare sculptures of the first half of the century (apart from Barye), did not seem born for oblivion and shame. His figures struggled and fought for life and recognition; they were not content to hide behind shrubberies. Nervous energy and strain was in every line of them. They seemed like

[1] A mosque in the Ak Serai quarter, built in 1870; it must not be confused with the Valide Mosque on the Golden Horn, which is an earlier building.

souls in torment, tortured with a self-knowledge that all too often was self-consciousness. They were the works of an egotistic age and corresponded to no innate social or national feeling.

Meštrović marks the return to a conception of sculpture as the exposition of the spirit of a race and of an age. His work is Slavonic rather than personal; he represents an innate feeling for art that had never really died out in the region that bore him, an art that is still latent in the Eastern Church. In this respect he is poles asunder from Rodin the egotist.

The years after the War saw a demand for sculpture for buildings and monuments that surprised the countries in which the demand was felt. Architecture has not as yet expressly avowed its need of sculpture, but on the other hand it no longer disclaims it. But the demand for sculpture was not met. The horrible war memorials that deface so many of the towns and villages of Europe are sufficient testimony. The post-Rodin school was, by its nature, unable to meet the situation. The interpretation of violent emotion or deep passion was hardly the quality required in the sculpture that was called for. Bourdelle alone of Rodin's pupils rises to the requisite heights, and he has cut clear away from the Rodin tradition and rightly gone back to an old national inspiration in his great memorial in Alsace. He seems to have felt that a national art was the only art for such work, and here he is on a level with Meštrović. The 'Vierge d'Alsace' is a brilliant synthesis of personal and national art, devoid of sentiment or moralizing, a monument that friend and enemy alike could admire. Eric Gill,

who has a few war memorials to his credit, achieves to a limited extent the same success in the English manner. His memorial at Leeds is thoroughly Anglo-Saxon in spirit but not so clearly so as some of his independent work. His 'Stations of the Cross' in Westminster Cathedral are like Saxon reliefs in a pre-conquest church. But his nationalism is unconscious and ancient, whereas Bourdelle's is deliberate and modern.

The post-war demand for sculpture is having a profound effect. It is creating both an interest in and a revival of sculpture. The failure to meet the demand has led artists to see that sculpture has a commercial future. In consequence a revival of sculpture is perceptible. Sculpture is no longer the forgotten step-daughter of Muses too busy to attend to her. The commercial sculpture which was the background in ancient Greece, against which the great masters were seen, is now almost again in process of growth. At present the dedicatory type of public monuments is its chief support. Tombs do not as yet call for the sculptor's art. But they may be the next step.

Sculptors are now beginning to realize that once they have stone or wood, or whatever material they may choose in their hands, it must not leave their hands until it has been transformed into a finished work. The handing over of a plaster model to be 'pointed' in stone by assistants, or, in other words, to be finished by others, is utterly alien to that love of the material which should be in the heart of every true sculptor. The use of stone is, as I have already said, conditioned by its supply. Greece here had the advantage with her inexhaustible marble supplies. The

vast quarries of Pentelic marble at Athens and those of the island of Paros still provide the only really fine marble for sculpture. Untouched deposits—whole mountains—of fine crystalline marble are to be found on the northern coasts of Greece: the islands of Marmora, 'the Marble sea' still provide a good grey-white marble for the buildings of Constantinople and Salonica. Throughout the Aegean region it is no expensive matter to build a private house largely of white marble blocks.

The Parian and the Pentelic are and always were the best marbles for sculpture that the world can produce. Sculptors prefer them to all others to-day as they did in ancient Greece. Their chief merit is that they have no cleavage lines and so are easy to work, if any hard marble can be called easy to work! The grain of each is not too fine and yet not too coarse. The value of a grained marble is that it produces an attractive surface which gathers the light and shade and shows off the subtleties of moulding and line. That is why Italian Carrara and Luna marble is the worst conceivable medium for sculpture. It gives a sleek and dead-white effect which makes the human figure in such stone look like a corpse lit by moonlight. These Italian marbles have the finest grain of any marble, and they resemble chalk in texture rather than stone. Pentelic has a clear sparkling grain and a faint tinge of gold, due to the presence of iron, which under exposure and by age creates a lovely patina. Parian, with a coarser grain, has a barely perceptible bluish tint which shows off to perfection shadows and moulding in a human figure. But Parian never patinates, and keeps its bluish tint. It polishes with a lovely smooth polish which

is vastly different from the glistening shine of Carrara and Luna marbles. It is the perfect medium.

To Meštrović is due the credit of reviving the use of forgotten sources of marble. He uses mainly the yellowish crystalline stone of the island of Brač, off the Dalmatian coast near Spalato. In addition he often carves in the oolitic limestone of the Istrian peninsula, which closely resembles our English Hoptonwood stone. Both these stones take a fine dull polish that enhances the beauty of the coarse grain.

Gill is largely responsible for popularizing one of the only two English marbles, the Hoptonwood stone. The other, that of the Isle of Purbeck, was much used in the Middle Ages but is little quarried to-day. Hoptonwood stone is a recent discovery and has no ancient use. Purbeck marble has a rich bronze colour and a dull polish that brings out the detail of the shell grain, for it is an oolitic stone almost wholly composed of rather coarse shell deposit. Hopton-wood stone is a dull cream colour with the shell-grain less evident; it takes a beautiful dull polish and is an ideal stone for formal sculpture.

Grey and yellow sandstones are used by English sculptors to a certain extent, but they do not polish and so are less satisfactory than the shell-marbles except for works which are expressed better with a dull surface. But in this case terra-cotta is an equally good and an easier medium. At the same time the Devonshire and Cheshire sandstones are easy to work, and it is surprising how little they are used. The full beauty of red sandstone, at any rate for architectural work, is now evident in the new Liverpool Cathedral.

The harder stones such as granite and basalt are naturally

not often used. Nor were they used in antiquity, except in Egypt, where time was long and labour cheap. Basalt can give a particularly lovely surface, as can be seen in a portrait-head by Meštrović, but it is a thankless medium.

Bronze is naturally the sculptor's chief medium and the *cire-perdue* process the only method that will ensure good results, even in the case of small bronzes. Barye moulded most of his bronzes in this way and produced a perfection of detail that added to the simplicity of his forms, except in those few cases where he over-elaborated. The only satisfactory alternative is the sand-mould, which with fine sand produces excellent results. Rodin was almost the first to initiate the practice of moulding from an unfinished work, unfinished either in the sense that it lacked certain parts that should structurally have belonged to it or in the sense that it had a rough-cast surface that was not smoothed and tooled by a final process and which showed, in consequence, the marks of the clay or of the mould. He did so mainly because he created rapidly and under a certain emotional stress. If the work were in essential character complete by the time that the creative *afflatus* had ceased he was satisfied, and the mood could not be recaptured. He was willing to let it leave his workshop without giving it the finishing touches that might have been thought necessary and which an ancient or medieval sculptor would certainly have given. Hence come his headless torsos, his bronzes on which the clay smears are everywhere obvious, the figures which often lack very large parts of their anatomy. He was an impatient artist and in many ways his impatience was justified by results. But unfortunately he started a fashion, and the

smaller fry found this summary treatment of sculpture a convenience under which to hide their inability. The fashion has lasted, and both Gill and Epstein are exponents of it. The former has many headless and legless works, many unfinished anatomies, while Epstein has brought the rough-cast bronze to a mud-pie perfection: nearly all his bronzes are smeared with countless finger-marks, in such a way that the bronze is little more than metallic clay. This seems to me a dire misuse of a splendid medium, whose very beauty rests in a fine surface and a smooth texture. Bronze really has no other use. To leave it knobbed and corrugated in the manner adopted by Epstein and to cover this uneven surface with a chemically-made patina seems little short of sacrilege. Epstein's true medium should be terra-cotta, and except in his rare work in stone he has the inspiration of a moulder rather than that of a carver.

Bernard, Meštrović and Dobson have used bronze as it deserves, and treated it more humanely. Dobson has gone even further and experimented in metal. He has used yellow brass, brought to a highly polished finish with great success in his portrait of Osbert Sitwell. The result is of great charm, because it emphasizes the formality of the sculptor's art. Epstein, by neglecting 'finish', gives a romantic or 'Rodinesque' appearance to what is essentially a formal style. If Epstein had kept to the manner of his fine tomb of Oscar Wilde in Père Lachaise it would not have been necessary to class him with an already *démodé* romantic movement.

Black stones other than basalt are rarely used, though there is a black Belgian marble (largely used for sculptured

fonts in the twelfth century) which takes a fine polish and has a rich warm tone.

Wood is a material largely used by Meštrović, Rosandić, and Gill. It controls the hand of the artist more than most materials because of the limitations of the grain. Boxwood alone is free from this limitation, but it can only be used for small figures, since the largest piece of boxwood available rarely exceeds a cubic foot in dimensions. Walnut is the best wood of all, and is largely used by Meštrović. Its grain is sufficiently close not to give serious cleavage. Ebony and hard tropical woods are used by some sculptors with success for small works and are coming more into fashion.

Terra-cotta was popularized by Maillol, who employed it both for large and for small figures. Dobson uses it with great success. It can be baked either a dull red or a creamy white. Its chief advantage is that it gives a soft surface which takes the light without violent contrasts. The soft lines of Dobson and Maillol, however formal they may be, are well suited to this medium, whereas it is impossible to imagine Rodin using it to express his varied emotions. In antiquity the only people to use terra-cotta with skill and success for large-scale statues was the Etruscans.

Colour and stone have been so long divorced in the art of sculpture that reconciliation is almost impossible. The technique of painted sculpture whether Greek, Gothic, or Cinquecento, is almost forgotten. The corpse-like pallor of post-Renaissance sculpture has set the fashion, the convention of unpainted stone being based, as is all too well known, on the fallacious belief that the ancients did not use colour. In fact no stone figure from 650 B.C. to A.D.

1600 in Europe was executed without some touch of gold or colour. The idea of a blank white statue was in antiquity and the Middle Ages as abhorrent as that of a bronze figure untouched by gold or silver or enamel or inset stone. Not that a statue in marble was ever coloured all over, but colour was used, in a rigid convention, for features such as eyes, lips, hair, and parts of the garments in order to bring out or emphasize the beauty of the stone by taking the eye off it from time to time (Fig. 1, A and B). This commonplace of artistic history has but little effect upon modern sculptors and has given them little inspiration how to use the two mediums together. The painted alabaster figures of the English Medieval School of Northampton, the painted archaic Greek or Gothic figures, the painted marble busts of Laurana, of Mino da Fiesole and the rest have left no tradition behind them. In terra cotta also the custom has always been at all periods to cover the whole surface with colour, because the medium itself has no peculiar beauty. Limestone and other coarse stones were, in Greece, treated in the same way: sometimes they were even coated with thick coloured pastes which were brought to a dull polish. Additions in bronze or gold or silver were made to marble reliefs in Greece (the Parthenon frieze had many adjuncts in bronze) and in Byzantine times. But nothing of this kind is attempted to-day except by Gill, who has applied paint to one or two figures in the ancient manner. Lips, eyes, and hair, and perhaps a necklace make some of his figures infinitely more attractive than if they were plain, without in the smallest degree suggesting that he has deliberately archaized or submitted to the teaching of the archaeologists. He has

merely found to be an additional charm that which was found to be charming in other ages.

At the same time it must not be forgotten that colourless sculpture can often do what coloured sculpture cannot. The origin of colourless sculpture and the original errors which begat it need not prejudice us against its use. The austere figures of Meštrović gain more than they lose in some cases by the absence of colour. Rodin's more violent works would be hardly tolerable with the addition of colour. Dobson and Maillol's terra-cottas are better as they are: colour would disturb the perfection of line and pose which these artists achieve. The Greek practice in bronze work of using silver for the lips and enamel or inset stone for the eyes might well be revived in highly finished or formal sculpture. It has possibilities for artists like Dobson or Gill, though for Epstein it would be out of place.

The modern chemical methods of patination of bronze cannot sufficiently be condemned. They are very rarely successful. Barye was able to achieve a variety of tints, none of which is very beautiful. A dull chocolate or a rich shiny verdigris green is the most common patination seen on modern bronzes. Each is equally unpleasant, the first being suggestive of what upholsterers use to give what they call an 'antique finish' to brass, the second suggesting that the statue has been dipped in acid (which is in fact the case). Time alone can give a beautiful patina, and it were better to leave the bronze surface with its own natural dull red or yellowish tint. Exposure to the air for only a few weeks will at least mollify whatever crudities of surface colour there are and lay the beginnings of a patination which will

rejoice later ages. You cannot patinate bronze artificially any more than you can 'age' wine by mechanical processes, though both are done. Simple hand-polishing, as Dobson has shown, can achieve an admirable finish that is not a patina; the custom might well be followed by most workers in bronze.

The Great War certainly created a demand for commercial sculpture, for humble memorials within the reach of the finances of villages and hamlets and even of private people of moderate means. The results are grievously disappointing. Academic figure work—by which I mean traditional figures devoid of personal style or character—has won the day and controlled the style of the minor and unrecognized sculptors. This is largely because they are asked for this kind of work by committees who sink any individual imagination that their members may possess in a common desire for compromise. Imagination in the artist or creative ability are at a discount. He will not get the commission unless he does what he is told. But the outlook is not wholly depressing. The demand for war memorials has, in turn, led to an increased demand for decorative sculpture on buildings. Here too the work has been left mainly in the hands of unknown commercial sculptors and masons. The few known sculptors have hardly been called upon. But the situation is more hopeful, for not all the buildings put up are controlled by committees. A broad-minded owner may give his architect a free hand, and he in turn may give some unknown sculptor his chance. Out of the great body of these unknown craftsmen it might have been thought that

some genius could by now have emerged in these days of rapid building. But so far we have seen no hidden master-hand. The reason, if obscure at first, is clear enough in the end. The friezes and antefixes, the pedimental groups and the panels in relief which decorate our newest buildings are executed in a style which seems born of a teaching long out of date. A Renaissance conception of antique mythologies interpreted in the manner of the eighteenth century and finished with the sleek pomposity of Edwardian baroque is the source from which the present generation of mason-artists draw. No more striking example of this bastard style could be found than the frieze which surmounts the top of a new pseudo-Renaissance building in Regent Street (Fig. 2).[1] A jostling crowd of allegorical and human figures extends before the eye. The figures contend both with their own tense tasks and with the presence of various abstract ideas or deities who are unevenly rendered in human form. To confuse still further this jostling scene, three presiding deities stand outside the frieze and behind it—for it is rather a balustrade than a frieze—and lean over as if to see what is going on in front. For long, while the building was in process of erection, I mistook these deities for two of the overseers. One is tempted to ask how a work so unpleasing came into being at all: and

[1] A pamphlet upon the building by Mr. E. Beresford Chancellor (2nd ed., N.D., p. 16), describes the sculptures: 'This frieze is unique in London. ... Over the top of the frieze three figures, watching the mercantile pageant below, break the skyline in the most arresting way. Like all novelties, this innovation has been subject to criticism, but, as a matter of fact, it not only gives a touch of originality to the whole façade, but vitalizes the conception in a very marked and effective manner.'

again why, now that it is in being, it is so extremely unpleasing.

The answer raises a deep and important problem. It suggests the fundamental questions: 'what rules ought sculpture to follow?'—'to what common practices are sculptors to conform if they are to achieve works of art?'—or alternatively: 'can a sculptor work by his own lights and without rules, without regard for the practices of those who have preceded him?'

Nine out of ten modern sculptors will reply that each man is his own rule and his own standard. To adopt the rules and methods of men long dead is to stultify and kill initiative and inspiration. To delve into a past of Gothic or Greek tradition is to archaeologize, and archaeology is the enemy of modern art because it always lays down the law and strives to dictate to artists what rules they should follow.

This answer is right. Archaeology can never and should never set the rules for modern art. It is a science of demonstration, not of instruction. It explains how ancient art was produced, what rules were followed, what masterpieces produced. The moment it suggests that these rules should be followed by all artists at all times it is clearly exceeding its mandate.

But without the discoveries of archaeology modern art might be less inspired and have less material from which to draw and adapt—and it is worth while investigating the rules and customs of ancient artists to see if by chance some permanent elements may emerge which we can find to be common to all great artists at all periods, but which have not been derived by any one from any other artist. The

Greeks were the last people on earth to lay down rigid rules and then expect those rules to be adhered to without change. The very essence of the Hellenic genius was new creation based on a perceptible but not violent deviation from fixed standards. The perceptible deviation of one generation became the revolutionary change of the next, until that in turn was obsolete convention. Thus was Greek art and Greek philosophy built up: thus did both achieve their fullest development within a period of 400 years; starting from zero. Greek art, particularly sculpture, made in its earlier periods more rapid strides than any other art has done in any other age. Within a hundred and fifty years of 650 B.C., which is the date generally accepted as that of the first dawning of sculpture in stone in Greece, the full perfection of archaic art was achieved—an astonishing achievement when we observe the two hundred and fifty years of sterility, say from 1600 to 1850. In this hundred and fifty years of rushing Hellenic genius, rules were invented, broken, and remade at full speed and high pressure. Between 500 B.C. and the time of Pheidias (roughly 450) even swifter advances were made. The archaic rules were thrown overboard, the master sculptors of Olympia revolutionized all art, and the weapons were forged anew. Pheidias adopted and adapted their inventions, and thereafter there were few fundamental innovations.

Now, if from this maelstrom of inventiveness and creative spirit, if from the numerous artists who worked and in the countless works that they executed we can isolate certain facts, certain rules, and certain practices in sculpture common to them all, we may rightly say that here is an irreduci-

ble minimum of common sense, call it 'rules' if you wish, which derives not so much from the workshops or the traditions of antiquity as from the store of permanent judgements of the human mind. If these 'rules' are observed in other great sculpture in other lands and at other times we have even greater sanction. No painter, after all, will paint without any regard for the precepts of his teachers. Nor will he disregard the laws of nature that concern his craft. Certain optical laws, after all, have to be observed in painting—as for instance the value of reds in foregrounds—which become by their nature rules of painting. So, in sculpture, certain methods satisfy the eye, others do not and never will. The Greeks discovered early, for instance, that sculpture in relief has to follow more rigid rules than sculpture in the round or else it will fail in its effect. Relief carving must be clear and definite in outline so as to catch the light on its main features. Hence they employed two rules: one that figures superimposed must recede in planes or steps which are more or less clearly defined and coherent within an intelligible system; and secondly, that figures must move laterally, that is to say they must be concerned with a left and a right, and not advance from or retire into a background. These, like all rules, must be broken at times, if only to prove their efficacy; but by keeping them in mind the sculptor is giving himself scope within reasonable limits rather than allowing himself the luxury of chaotic licence. Nearly all Greek archaic sculpture observes these rules—practices were a better name. The fifth century sees them universally followed—perhaps too closely—with the solitary exception of the reliefs from the temple at Phiga-

leia, where figures advance and recede from the background. But both the temple at Phigaleia and its sculptures are a bold experiment by a bold author and, as such, have no parallel.

The charm of early Greek relief work lies in its clear-cut composition, in the ease with which the eye moves from one figure to another, and in the compact character of the design or subject represented. Nearly all modern sculptors have followed the Greek method, not so much because it has the sanction of age as because it has the merit of success. Reliefs like those of the Cnidian frieze or the Ludovisi Throne command instant admiration. They show the hands of great artists getting the best out of an accepted method. Meštrović, Gill, and Bourdelle have adopted the system of planes and of lateral movement. If anything, they have over-simplified the Greek method which, in itself, is capable of infinite subtleties. Meštrović often, perhaps too often, employs two planes only, particularly in his reliefs in wood: many of his reliefs in the Cavtat mausoleum are of the same simplicity. But he can elaborate the theme and make the most of it. Gill, however, shows too little capacity—at least in the 'Stations of the Cross'—of making the most of an elastic convention.

Most of the commercial sculptor-masons of to-day seem to have no idea at all of the refinements of these Greek methods. Possibly they disregard them as old and obsolete. Perhaps they have never seen Greek sculpture at all. As a result we get relief work which is in low relief at the background and in high relief in the foreground, often with figures so highly cut as to be almost detachable. Uncon-

sciously in their modern disregard of an ancient practice they are following the methods of another period. In late Greek and Imperial Roman times the archaic rules were forgotten. Figures jostled in unheard-of confusion on sarcophagus and frieze (Fig. 3). So detachable were some of them that the antiquity-dealer has, all too often, successfully detached them and sold them as separate works of art. At one period of Graeco-Roman art relief sculpture indulged in a pastoral mood (Fig. 4). Landscapes with an infinite regression of distance were rendered: figures moved almost exclusively from back to front of the screen. This is a painter's sphere, not that of a sculptor, and there is every reason to think that at this time the sculptors came profoundly under the influence of the painters. To-day reliefs such as we see on so many new commercial buildings give us the same Roman and Hellenistic methods. Landscapes and distant views, jostling figures that nearly fall out of the scene, and figures in low relief at the back make up a medley of styles and mediums that shocks the eye and stuns the imagination. Calm, simplicity, and order are not found there because they do not exist in the mind of the makers. Too many modern sculptor-masons seem to think that a technical ability to model a human form justifies them in attempting a relief. They learn all too late that relief-carving is an art in itself. The chaos to which it was brought in Imperial Roman times changed slowly back again to order. The spirit of what we call Byzantinism slowly infused its love of accuracy and simplicity into late Roman art. Back came the old rules again and relief sculpture was Hellenic once more. Possibly the Byzantine sculptors of the tenth and later centuries

went a little too far in their unconscious revival of antiquity. Meštrović, who is of their kin, does what they did as skilfully and as severely. The Byzantines, like Meštrović, rarely used more than two planes. But they achieved the fullest results from this simplicity.

Chiefly, I think, it is simple ignorance that encourages our commercial sculptors to carve their uneasy masterpieces. They have, I imagine, never seen a fine Byzantine relief or a gem of Greek archaic art. Why, after all, should they have seen them? Are they not educated in the dim art-schools or architects' offices where the repertoire of antiquity is usually limited to a 'Dying Gladiator' in plaster and a slab of the Parthenon frieze grime-covered and faded?

With sculpture in the round the position is different. Here a sculptor-mason or a mere stone-cutter will not do. The work requires greater technical knowledge. But there are rules just the same, though they are less complicated. The sculptor has to decide whether his work is to be seen from all points of view, or from some, or from one only. Some critics [1] speak as if the evolution of sculpture was from the unifacial to the plurifacial, as if a statue seen only from the front were primitive and one seen from all angles with equal pleasure the last word in a perfected art. If this were so the Apollo of the Olympia pediment would be inferior to the statue of John Stuart Mill on the Thames Embankment. Obviously some sculptures derive their highest value from being seen only from one point of vantage—the por-

[1] e.g. Mr. Raymond Mortimer in his preface to a monograph on Dobson in the series 'British Artists of to-day' (1926).

trait of Mme Banaz (Fig. 20), by Meštrović, is a case in point. The interpretation of two different methods as being two stages in development is clearly foolish. They are merely two methods, each of which is suited to a certain set of circumstances and to certain intentions of the artist. It is true enough that a primitive artist thinks only in terms of frontality or profile, but it is clearly illogical to infer that the use of a frontal view or a profile view is therefore the sign of a primitive art. It is the sign of formalism.

Actually, a 'free' statue which can be seen to equal advantage from all points of view is difficult of achievement. Benvenuto Cellini's 'Perseus' is, perhaps, a typical example. Neither equestrian statues nor full-length portraits can be considered as 'free'. Equestrian statues are almost invariably seen *en profil*, portraits *en face*. A sculptor can only escape from the meshes of frontality or profile-view by getting a twisted spiral form in some way into his figure. The Hellenistic Greeks solved to perfection the problem of escape by swinging the body round on its hips so that the shoulders were at right angles, or more than right angles, to the horizontal axis of the hips. Fauns and Satyrs who twist round to look behind them, to dance or to posture, solve this difficult technical problem in the easiest way. By having a spiral structure in the body they compel the observer to walk round the figure in order to see it as a whole. This is the simplest solution and it is mechanical and automatic. Bourdelle in his 'Heracles' (Fig. 8) solves it, or almost solves it, more subtly, but still does not quite escape from frontality. The question then arises: 'is it really the function of statues to be seen from all possible points of

23

view?' Many artists and many ages have tried to solve the problem. In the long run the finer sculptors tend to avoid the plurifacial. Some few works like the 'Perseus' are successful, but the majority of fine statues like Rodin's 'Age of Bronze', Bourdelle's 'Vierge d'Alsace', and Meštrović's portraits are all to be seen *en face* or *en profil* and from no other important aspect.

ILLUSTRATIONS TO CHAPTER I

A. The head and shoulders of a complete figure of a maiden, excavated on the Acropolis at Athens and now in the Acropolis Museum.

This statue, which is a little less than life-size, is in many ways the most beautiful of all the series of lovely maidens of the Acropolis. It was cut about 550 B.C. in Athens and is almost the earliest of the series.

The hair, eyes, and lips are lightly painted, the hair reddish-brown, the iris of the eye and the lips in dull red. The embroidery of the garment is picked out in blue-green. Ear-rings, probably in gold, were in the ears.

There was no attempt at naturalism in the colouring any more than in the style. But without these quiet tints the figure would have been lifeless and dull.

B. Head of a Persian from the so-called 'Alexander Sarcophagus', found at Sidon and now in the Ottoman Museum at Constantinople. Here the colours are brighter and more natural. The eyes are brown and the oriental head-dress purple. Other figures on the relief have garments on which bright blue, yellow, and crimson are used.

The reliefs of the sarcophagus are high, but still conform to the old rules. The style is that of the school of Lysippos at the close of the fourth century B.C.

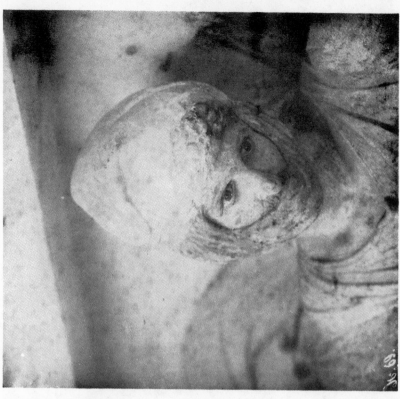

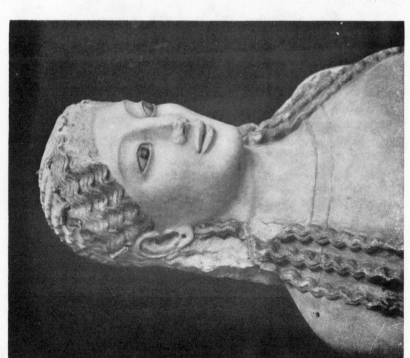

A
B

1. GREEK SCULPTURE WITH THE PAINTING PRESERVED

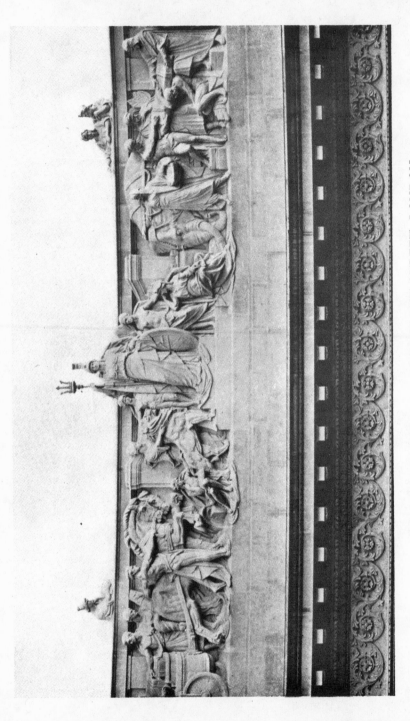

2. FRIEZE ON A BUILDING IN REGENT STREET, LONDON

This great relief which, as frieze or balustrade, surmounts an imposing new building in Regent Street, London, is in limestone. It measures 115 feet in length and the figures on it are 7 feet high. It represents 'the wealth of the East and West being borne by ship, camel, elephant, &c., to Great Britain, which is typified by a central statue of Britannia' (p. 16 of a pamphlet describing it).

The composition is clearly good, but the sense of formal relief evident in the figures of the horses and the lion is contradicted by the treatment of the human figures, which are almost in the round. The overlapping of the composition beyond its framework and the figures behind effectively nullify the formalism which such a subject demands.

The central portion only is shown here.

# DESCRIPTION OF FIG. 3.

A sarcophagus of the Imperial Roman period in the Capitoline Museum at Rome. It shows, in the relief, scenes from the life of Achilles. The style and subject are based on the Hellenic, but nearly all the Hellenic methods of relief work are forgotten. The eye is exhausted by the confusion of figures and there is none of the simplicity of Greek work.

3. ROMAN SARCOPHAGUS

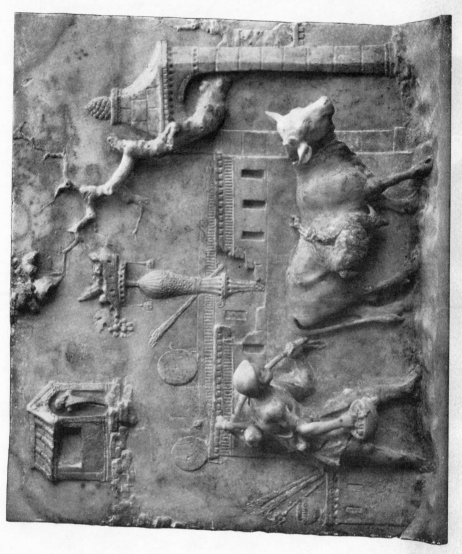

4. GRAECO-ROMAN RELIEF

## DESCRIPTION OF FIG. 4.

A relief of the time of Augustus in the so-called 'Neo-Attic Style', perhaps the work of a Greek artist. It is now in the Glyptothek at Munich.

The pastoral scene shows a herdsman returning from market. A shrine with harvest offerings and a sacred tree is just behind him. Away in the distance on a hill is another shrine of a rural god.

Originally details were added in paint and the main figures and objects also painted. It is hard to see why stone was used at all for so unplastic a subject.

All the old Hellenic methods are here abandoned and the sculptor is deliberately attempting to use stone in a new way.

## THE MASTER AND PUPILS OF RODIN

*Barye the Pioneer. Maillol and Bourdelle the Hellenists. Bernard the Independent. Despiau.*

THE sterility of the art of sculpture during the last half of the eighteenth century and the first half of the nineteenth is a phenomenon almost without parallel in the history of art. The period might be extended considerably backwards, and certainly forwards well beyond 1850. The causes are not very evident: the effects, however, are overwhelming and disastrous. Once art shuts its eyes to plastic forms vigour leaves it. The supple simplicities of David in France (I need only quote the 'Rape of the Sabines' as an instance) and, at a later date, the fleshy strivings of the pre-Raphaelites satisfied what latent cravings there were among artists and the public for a fuller sense of form in the round, for solid achievement, and for work that was satisfying in all three dimensions. Figures began, in the shocked words of the Greek priest, 'positively to step out of their frames'. The relative Byzantinism of earlier periods of formal portraiture gave way to the lush shapes of Burne-Jones and Watts, and the need for sculpture was met, in England at least, by a coloured and fleshlike compromise.

One of the first to cut clear from the tyranny of paint was that remarkable man Barye, who thought only in terms of life and movement and sculptural forms. By a patient and scrupulous observation of animal life he taught himself as an artist to seize upon and crystallize in sculpture

not, as with his predecessors, immobility, but swift action itself. The great majority of his work consists of momentary action, of sudden movement begun or ended, and of repose only as *attentive* or *expectant* repose. Barye watched nature in action and achieved his masterpieces on a basis of close observation. In his capacity of Professor of Zoological Drawing, a post which was created for him to prevent him from starving and which he accepted with distaste in 1854, his lectures were concentrated down to a sentence— 'Regarder la Nature et prendre un parti : quoi professer devant cela ?'

The productivity of his long life (he was born in 1796 and died in 1875) was as astonishing as that of Meštrović or Rodin. Certainty of knowledge, absolute accuracy of observation, and a complete absence of self-consciousness stamp his work as revolutionizing an outlook in the art of sculpture. No wonder that he fought intrigue and starvation and only achieved recognition when he was over seventy years of age. He never left Paris, and yet created works of art in animal life which might have been based upon a long experience of animal life in the jungle. His careful observations and sketches of living animals in the Jardin des Plantes and his dissection of their dead bodies gave him a knowledge which he used as a true artist. Hence he was able to create fantastic shapes whose anatomy was correct, if such a term can be used of the non-existent. His 'Theseus and the Minotaur' (Fig. 5) is a revelation of what new vigour his art had brought into the world. Here is no study by a mere 'animalier'; it is a work that forestalls half a century of sculpture, even if it is only in miniature forty-seven centi-

metres in height. With it we can class his 'Lapith and Centaur' (Fig. 6), a brilliant conception that uses the antique as a means to an end rather than as a model to copy. His 'Victory' belongs to the same style and group, a figure in which the outlines of Maillol and Bourdelle seem latent. His sketch for a 'Figure antique' is even more expressive of the fact that he had learnt from his observation of ancient art as well as from his observation of nature. In each case he creates and synthetizes but never copies. His only fault is his love of superfluous detail on and around the bases of his small sculptures and bronzes. It is a weakness derived from his early life and training as a goldsmith. His 'Tiger devouring a crocodile', one of his earliest works, has this defect more than most. He could never cure himself of the idea, which was indeed firmly implanted in the minds of his patrons, that his small bronzes were ornaments of use, paper-weights or mantelpiece decorations, and he decorated them with unnecessary adjuncts in the manner of the time. But his art stands out clear and dignified, revolutionary and creative, in works like 'Theseus and the Minotaur'.

Thus in a sense Barye marks the turn of the tide in modern sculpture. Movement and life based upon accurate observation were not the aims of the sculptors of the two or three centuries which had preceded him. The monumental solidity of the works of Canova, Thorwaldsen, or Flaxman belong to another and an inferior world of art.

In 1864 Rodin became the pupil of Barye, and the influence of the master left definite and unalterable stamp upon all the work of the pupil. In the drawings that Barye has left, which in some ways show his power to the best

advantage, one can see the swiftness of vision and simplicity of line that stamp a real master. The curiously oriental touch that is seen in some of Barye's animal drawings[1] is but an indication that he and the oriental masters alike knew how to omit the superfluous in the rendering of movement, tension, or stability.

The work of Rodin follows step by step the teaching of his master Barye, but transfers to the human form the principles explicit or implicit that Barye had followed in his treatment of animal sculpture. Rodin's practice was to have several models and to observe them in movement, seizing as they moved upon certain actions or attitudes or motions and at once memorizing them. It was his conscious attempt to do what the sculpture of Ancient Greece had done as a normal procedure from their constant observation of public athletics, or what oriental painters had always done —to memorize from observation and then to create a synthesis of the memories so stored. 'I am not at the orders of my models', said Rodin,[2] 'but at those of Nature.' You cannot treat the human form as a motionless doll, he explains, without producing works of art that are artificial and dead. 'Even in my less mobile statues', he says,[3] 'I have always tried to give some hint of movement: I have rarely shown complete immobility. I have always tried to render the inner feelings by the mobility of the muscles.' Even in his portrait busts, he explains, he gave some expressive torsion or hint of movement. In brief, 'movement in art is the transition from one attitude to another'.

---

[1] Notably in one published by the Vasari Society (1927).
[2] P. Gsell, *L'Art* (Paris, 1919), p. 38.    [3] Ibid., pp. 80 and 92.

But his very insistence, which sometimes seems exaggerated, on mobility and life gives to his works what has been described as 'l'étrange malaise de l'âme ligotée dans le corps'.[1] Rodin's works in most cases give the observer an inexplicable sense of discomfort. One of his earliest works, 'L'Homme au nez cassé', by this *malaise*, but more, perhaps, by its bold originality in a world accustomed to the soft banalities of academic standards, caused an outburst of disapproval and was refused by the Salon of 1864. But in 1875 Rodin visited Italy, and under the influence of Michelangelo modified his vigour. 'Pour moi,' he said, 'j'essaie de rendre sans cesse plus calme ma vision de la Nature. C'est vers la sérénité que nous devons tendre.' This he said towards the end of his life, and it is hardly illustrated by any of his works. The *malaise* was in his blood, and his ambitions were never really achieved. It was as if he had at last discovered the real fault that underlay most of his work and much of his theory.

Perhaps the complete absence of architectural feeling in his work gives it that uneasiness that troubled those Greek masters who were the first to divorce sculpture from the architectural setting in which it had been born. 'What could be more distorted or fussy than Myron's Discobolos?' said Quintilian, a critic of refinement and acuteness. The remark applies to much of Rodin's work, in particular to those semi-articulate and crowded compositions, partly as it were in relief, partly in the round, like 'La Vague'[2] or 'La Source',[3] where figures and matrix swirl in uncertain

[1] P. Gsell, *L'Art*, p. 231.  [2] In the Musée Rodin. No. 40.
[3] Ibid. No. 28.

and chaotic form. Rodin is rarely purely symbolic. His 'Main de Dieu, ou la Création'[1] is one of his most impressive works. A hand, living, powerful, and immense, clasps a clod of earth from which a male and female figure tumble. It is impressive, but it reeks of what can only be called 'cosmic sentimentality', and one is doubtful if it is the proper medium for the expression of the idea.

Throughout one feels this uneasy stress, a perpetual striving to make stone *interpret*, to make it symbolic or expressive of ideas which belong to a world other than that of art. Had Rodin been an Englishman I feel sure that his art would have 'taught a lesson', that he would have been approved of by the higher moralists of the later nineteenth century. Conceivably this explains the sympathy which Rodin always had for England. He did, in fact, find much in common with English ideals—they tend to favour the Higher Sentimentality in art.

The absorptive effect of Rodin's art upon sculpture for fifty years after his first activities is a testimony to the force and vitality of the new artistic ideas which he represented and had largely created alone and unaided. Interest in sculpture and the activity of sculpture were, during the second half of the nineteenth century, at an astonishingly low level. This, in part, accounts for Rodin's predominance in the art of that period; but his personality and his insistence on the interpretative side of art contributed in the main to this end. No modern sculptor had as yet in modern times used stone and bronze as a vehicle for the expression of the more

[1] In the Musée Rodin. No. 71.

powerful emotions nor yet for the more elusive. 'Despair' [1] and the 'Prodigal Son' [2] or 'Paolo and Francesca' [3] at one end of the scale are balanced by 'The Age of Bronze' and 'Balzac' at the other. 'La Pensée' (Fig. 7) represents an even more rarified form of semi-emotional or almost intellectual activity, rendered through the unaccustomed medium of stone.

But while Rodin was ranging, like a forgotten centaur, through the Olympian forests, seeking to understand and explain the emotions of mankind in stone and metal, students of sculpture whose simple aim was the creation of the beautiful drew technique and style from him—and what finer source could they draw from?—but left philosophy and symbolism outside their studios. Serenity and simplicity came unasked to these simple men.

Two sculptors, each born in 1861, Aristide Maillol and Émile-Antoine Bourdelle, rank among the most remarkable of modern artists, and both were indirectly influenced by Rodin. The former, a Perpignard, learnt much from a voyage in Greece in 1909 and 1910, and clearly formed his own views on ancient art independently of the rather distorted interpretation of it held by Rodin. Bourdelle, after 1885, worked under the direct influence of Rodin. Yet both these sculptors, who can rank perhaps higher than any of their generation, achieved in their own ways curiously similar results. The Rodinesque *malaise* has vanished, but his vigour

[1] In the South Kensington Museum. *Catalogue* (1925), pl. xviii. There is also a version in marble.

[2] Ibid., *Catalogue*, pl. v.      [3] In the Musée Rodin. No. 67.

and force has survived in their work. Maillol has achieved a remarkable calm in composition and execution after the stress and striving of the Rodin manner. Bourdelle, in many ways a greater artist, has an invention and vigour that Maillol lacks. His 'Heracles the archer' (Fig. 8) in the Luxembourg is one of the most inventive and satisfactory sculptures of to-day. Achieved as early as 1908, it marks a turning-point in modern sculpture. The formalism of the face and the attitude of the Heracles balance evenly with its amazing vigour. Tenseness rather than motion is portrayed. Here is no 'transition from one attitude to another', but motion seized at the summit of its tension. It is a work which the vocabulary of Rodin could never have expressed. Nor does it bear any direct relation to the antique. I know of no ancient Heracles which it resembles even remotely. And yet it owes its existence to the antique and would command the respect of any Greek sculptor. A second head of Heracles by Bourdelle, in a different manner, also in the Luxembourg, is closer to the antique, and Lysippean in manner, but it does not carry so much conviction as the head of this Heracles. Here we see the true man of strength, half god, half fool, of classical legend, but in a way that is new, interpreted in a fresh but not un-Greek manner. That is the secret of so much of Bourdelle, he can assimilate the spirit of other ages. The Heracles has an architectural flavour. Much of Bourdelle's work is like this. It might be the central figure of a pediment of a temple and yet it is an essentially modern conception: it shows a Heracles as we know him to have been but as no ancient actually thought of representing him. Bourdelle is using antiquity in a

legitimate way, and the cry of 'away from the antique' has no validity in the presence of such a work. This is not archaizing, yet no Greek would have given anything but praise to such a work.

The 'Centaur' (Fig. 9) is a similar and equally great performance. He stands dying and defiant on a mountain. His human body is lithe and sinewy, taut and swift. The hooves and legs of the horse-body are stocky and shaggy, thickset and solid. Here is a true blend of the two elements in a manner seldom achieved with such success in antiquity except at Olympia.

Maillol and Bourdelle have both been called 'Greek'; but the former is 'the aristocrat, the type envisaged by Aristophanes'.[1] Bourdelle is another type altogether, the type 'who is troubled in his heart because he scents barbarians near at hand'.

Above all Bourdelle is a sculptor with an architectural sense. 'No work of his can remain, as is the case with certain of Rodin's works, the slave of a block of stone, of still living stone to which it stays bound.'[2] Both the 'Centaur' and the 'Heracles' imply an architecture. Bourdelle's reliefs on the Théâtre des Champs-Élysées show him working *con amore*.

The 'Vierge d'Alsace' of Bourdelle (Fig. 10), perhaps the most noble of all monuments of the Great War, was made to go upon a hillside at Niederbruck in Alsace; it is more than three times natural size and is, in some ways, his *chef-*

[1] François Fosca on Bourdelle (p. 7) in the series *Les Sculpteurs Français Nouveaux* (1924).
[2] J. L. Vaudoyer, quoted (p. 18) in the same work.

*d'œuvre*. It is a successful blend of early French Gothic and archaic Greek, a blend the easier to achieve since the two phases of art solved the same problems in an almost identical way. The Byzantine formality of the drapery harmonizes with the simple archaism of the faces: yet there is no eclecticism, it is an essentially new work, and can rank among the masterpieces of this era. The Virgin stands in the attitude common to French statues of the fourteenth century, with the weight of the body on the right hip, the body itself curving gently, an attitude which is one of the great contributions of early French art to sculpture. On the right arm of the Virgin stands the infant Christ, with arms outstretched in the Cross and supported standing upright by both the hands of the Virgin. The curving lines of the two arms of the Virgin balance to perfection the outer curves of the drapery she wears. The lines of drapery from the waist down repeat the lines of the body beneath in that harmonious rhythm which was one of the most notable inventions of Greek sculptors of the early fifth century. Bourdelle has synthetized from the past and used its discoveries anew as only a great artist can.

Works like this show perfection of composition that one does not find so clearly in Maillol. Bourdelle's sketch of 'Pygmalion and Galatea' (Fig. 11) shows his power of swift creation even more strongly. The drawing is the product of a mind that thinks in terms of mass and balance and swing of line.

In his less ambitious creations Bourdelle does work that has all the repose and suavity of Maillol. 'La Baigneuse' compares so closely with Maillol's numerous figures of

women that one can here see the common ideas, the common 'Hellenism' if one wishes, of the two artists.

In his portraits, which are not numerous, Bourdelle goes to those sources which inspired the portrait-cutters of Greece of the third century B.C. His Hellenism is in his methods and in his outlook. The magnificent bust of Anatole France (Fig. 12) bears a surprising but unintentional likeness to ancient portraits of Epicurus. In neither case is the portrait slavish or overloaded with detail. There are few modern portraits that can compare with this in its simple exposition of personality. It is the portrait of a great man cut by a great artist, and by a man who could understand his subject better than any other.

Maillol, unlike Bourdelle, fears no barbarian intrusion. He has a simpler manner and a more serene outlook. But he has less imagination and more conventionality. Like Bourdelle he uses memory and visual image more than direct observation. But he has a unity of subject as well as of treatment. He has a passionate predilection for the human figure and a clear eye for its use in design. His monument to Cézanne is like an Etruscan sarcophagus seen through modern eyes. It shows a muse reclining on a draped couch holding a wreath of bay-leaves in her left hand. The figure and the basis form a coherent whole. As design it is perfect simplicity.

To the world which Rodin first scandalized out of its academic stupor and then lulled to sleep in a sense of security Maillol and Bourdelle must have appeared as intruders, but not as revolutionaries. Rodin's force of character and immense output had overpowered opposition at last. But

at the same time he had set a standard which was copied by countless minor workers and which culminated in a vast output of Rodinesque sculptures which sicken the eye and try the patience. There is reason to think that the painful decorative style of the early years of this century known as 'Art nouveau' was derived indirectly from the Rodinesque manner; for there is in so much of Rodin's work an obtrusiveness of purpose and design which is closely allied to simple vulgarity.

In a sense Rodin had established a New Academicism. New methods in sculpture might have raised just the same protests that had first greeted Barye. But Maillol and Bourdelle achieved their position by the very softness of the transition between Rodin's style and theirs. The difference is great enough but the transition was easy, and Rodin himself had borne the brunt of a transition far more violent and brutal, even though Barye had preceded him as pioneer.

The importance of Maillol lies, perhaps, mainly in the fact that he shows the real meaning of 'classicism'; he shows how antiquity should be used and what the real value of an ancient sculpture can be for a modern sculptor. He is the very antithesis of Flaxman or Canova. His work is Greek in the spirit in which it is carried out, in the ease with which it is executed, and in the absence of strain in the accomplished work. Rodin was baroque in comparison. If, as has been said, Hellenism implies the absence of prejudices rather than the presence of a theory, then Maillol's work is certainly Hellenic. His figures have no tricks: they contain no profound thoughts, but they are entirely self-sufficient. He is, as an artist, entirely at his ease within

certain limits which his own mind has set—and this, in brief, is Hellenism. He has specialized in the human form and chiefly the female form (Figs. 13, 15). If his contribution were no more than that, it would still be great. He has led art back from the fevered world of Rodin; his women are all divinely at ease, graceful and languid like souls in the Elysian fields. There is no more of the terrible striving of the flesh that Rodin depicted. In the place of 'Transport et Ravissement', 'Fugit Amor ou la course à l'abîme', and such titles we get with Maillol little more than 'Baigneuse'. This change, apparently trivial, is in reality deeply significant of the gulf between Rodin and his pupil. Even in the very lovely monument to Cézanne (which the municipality of Aix, Cézanne's native town, refused with scorn to accept) the figure is similar to most of those in his convention; it is devoid of passion, as calm as an Attic mourner in Cerameicos. And yet the greatness of Rodin lies in the fact that he could inspire such a pupil without driving him into opposition.

Maillol's most finished work is, I think, his 'Young Runner' [1] (Fig. 14 A and B), as perfect a work as any victorious athlete by Polycleitos, yet in no sense a copy or version of the antique. It is the most 'real' of all his works in the sense that the formalism that is so evident as to be a convention in the 'Baigneuses' is less evident here. It is a work full of thought and care: Maillol has set himself the task of rendering a perfect form with perfect ease, and he has taken infinite pains. 'It is the finishing touches which give the real trouble,' said Polycleitos. [2] Maillol in this work alone of all his works

---

[1] In bronze in the Luxembourg Galleries.
[2] This seems the true sense of a difficult and disputed phrase.

seems to have thought the same. In the 'Baigneuses' the expressionist treatment of surfaces and the absence of detail emphasizes the general swing and balance of the figures: they are archaic in their simplicity; no detail attracts the eye away from mass and line. The faces in the same way are calm, untroubled, like those of archaic goddesses. It has been well said of Maillol that 'in this fevered age in which we live his art shines out with a vivid brightness which illuminates as did the antique works of art which were found in Italy at the Renaissance'.[1]

Not unlike the work of Maillol is that of Joseph Bernard. Both alike belong to the same inspiration as Renoir, of whose work in stone there is all too little. Bernard also worked under Rodin, but like Maillol he has emancipated himself from the shackles of the master. His finest work is in the female figure, which he has formalized in a way more vigorous and striking than that of Maillol. His two bronzes, 'Jeune fille à la cruche' and 'Femme et enfant dansant' (Fig. 16), both slightly above life-size, give the fullest aesthetic satisfaction. They combine in a curious way stiffness with suppleness, rigidity with balance, and are strongly formalized. The structure of the figures is essentially right and there is no realism or photographic accuracy: his figures are like figures moving in a dream. Bernard may not be a great sculptor, but he has accomplished distinguished work. He has more imagination than Maillol and greater powers of invention. His work will yet have a great influence on contemporary sculpture.

[1] Waldemar George in *Maillol* (*Albums d'art Druet*), p. 6.

Despiau, also a pupil of Rodin, has equally freed himself from the manner of the master. In some ways he represents a reversion to the academic ideal, yet to an academicism that belongs rather to the Renaissance than to Greek or Roman antiquity. His principal strength is in portraiture, often (as in the bust of Mme L. H.) reminiscent of Laurana, but more often in the manner of French work of the fifteenth and sixteenth centuries. Yet his work is essentially original: there is nothing eclectic in it and no deliberate plagiarizing. He has also to his credit several nudes which differ but little from those of Maillol and have the same inspiration.

# ILLUSTRATIONS TO CHAPTER II

This little bronze, measuring 47 centimetres in height, was executed in 1848. In this, as well as in the work shown in Fig. 6, Barye definitely escapes from the charge of being a specialist. Here he shows his hand as a distinguished and original sculptor. The figure of Theseus in its calm rigidity contrasts with the frantic struggles of the centaur. Both in attitude and in detail the Theseus owes much to the antique. Barye must have seen the famous group (in the Roman copy at Naples) of Harmodios and Aristogeiton, the Tyrant-slayers.

The hair of Theseus is treated in the archaic Greek manner. The group is intended to be seen from one point of view only.

A plaster version, probably the original of this bronze, is in the Zoubaloff Collection. A bronze version is in the Louvre.

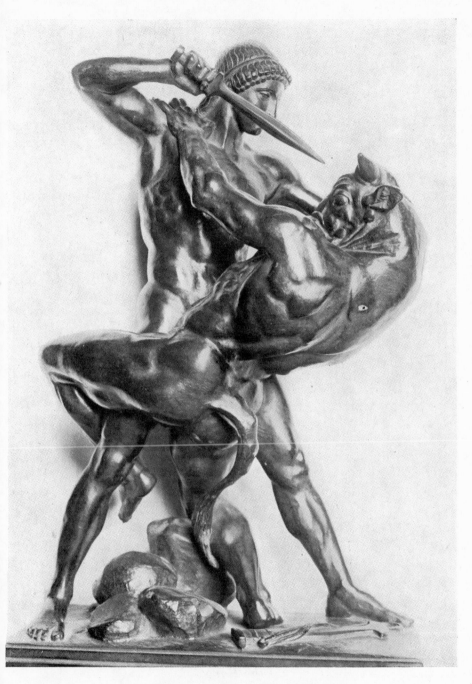

5. THESEUS AND THE MINOTAUR
*by Barye*

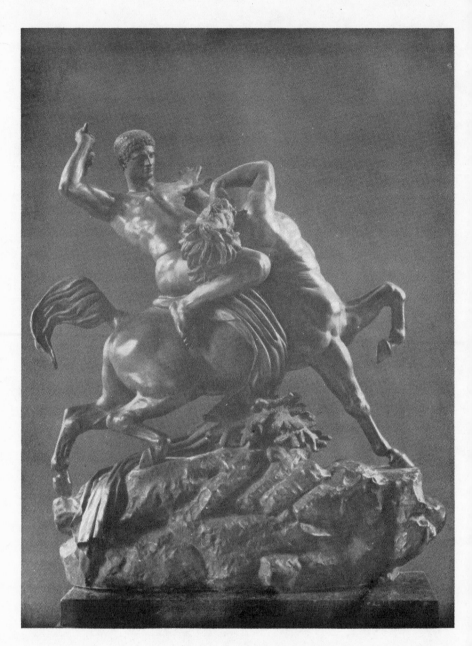

6. LAPITH AND CENTAUR
*by Barye*

This small bronze was exhibited in the Salon of 1850. The version shown here is in the Louvre and differs in certain small details from another copy in the Zoubaloff Collection.

The composition is reminiscent of the Dirce group in the Naples Museum, a copy of a late Greek original, and a not very inspiring source. Barye has here improved vastly upon it, but the bronze is over-patinated and the detail fussy.

Here Rodin is seen in his least emotional aspect. The contrast of the exquisitely finished head and the crude block from which it emerged is deliberate. But the effect is rather that of a philosophical lecture on Mind and Matter; the sculptor is taking liberties with his medium. The work is in the Musée Rodin.

7. ' LA PENSÉE '
*by Rodin*

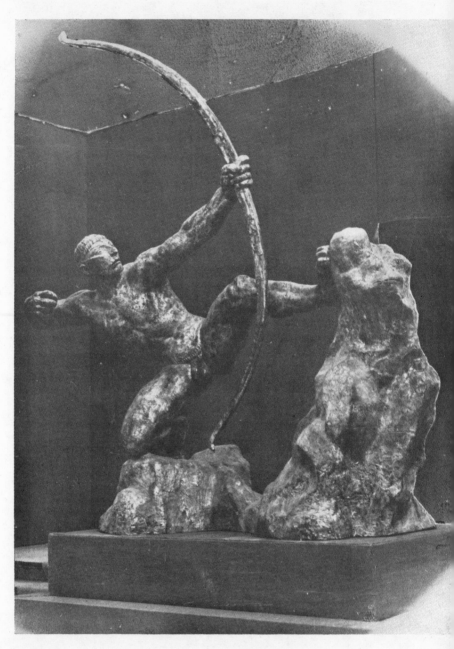

8. HERACLES THE ARCHER

*by Bourdelle*

## DESCRIPTION OF FIG. 8

This version, in gilt-bronze, is in the Luxembourg Gallery. It was made in 1909, after a first state in 1908. The impression of tremendous physical power that it conveys is unequalled in modern sculpture.

The work is above life-size and is essentially true to its medium in that it uses bronze to achieve an attitude and a balance that would be impossible in stone.

The arrangement of masses is most carefully thought out and the mighty bow gives the vertical line that is essential to the composition.

This ponderous figure of a Centaur should be studied closely with that of Heracles. It has the same general qualities, but shows physical energy slowly failing rather than at full tension. The Centaur's head falls over on to his left shoulder, for he is dying. The whole mighty body is on the point of collapse.

The original model, of which there is a photograph is now in Bourdelle's studio. Several bronze versions have been made from it.

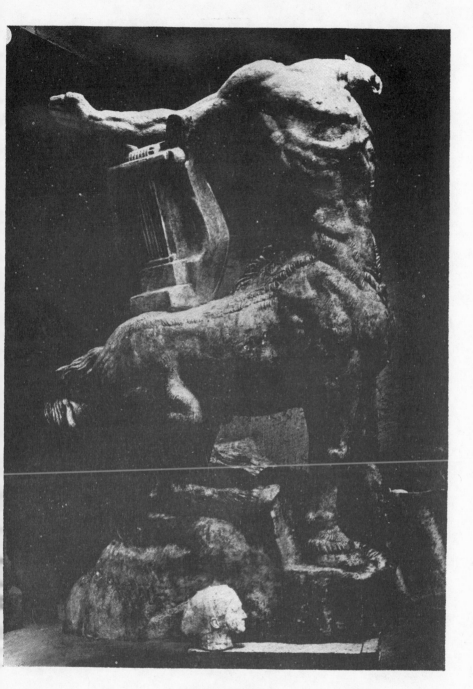

9. CENTAUR
*by Bourdelle*

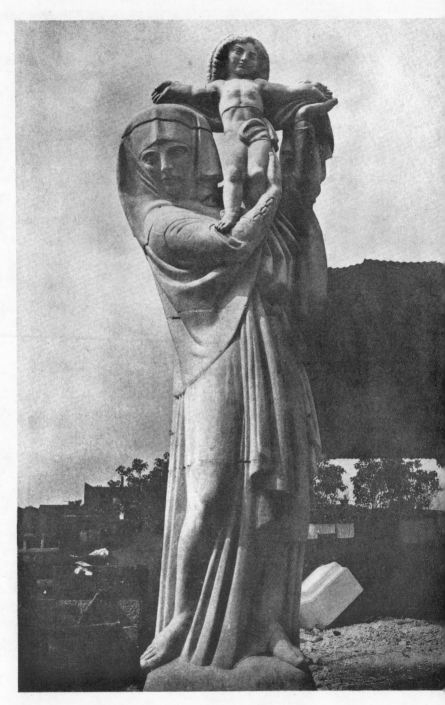

10. 'LA VIERGE D'ALSACE'
*by Bourdelle*

Here is a statue on a colossal scale, meant to be seen from afar. It stands now on a hill-top in Alsace and was cut between 1920 and 1922.

In no other work has Bourdelle shown such supreme skill at formalizing drapery and making its lines significant. There is nothing redundant or superfluous in the figure. The sculptor has here grasped and expressed the essence of French medieval art.

In this sketch, in ink and water-colour, we can see how perfect is Bourdelle's power of composition and rhythm. The cloak on Pygmalion's shoulder completes the picture by continuing the flowing lines of the figure of Galatea.

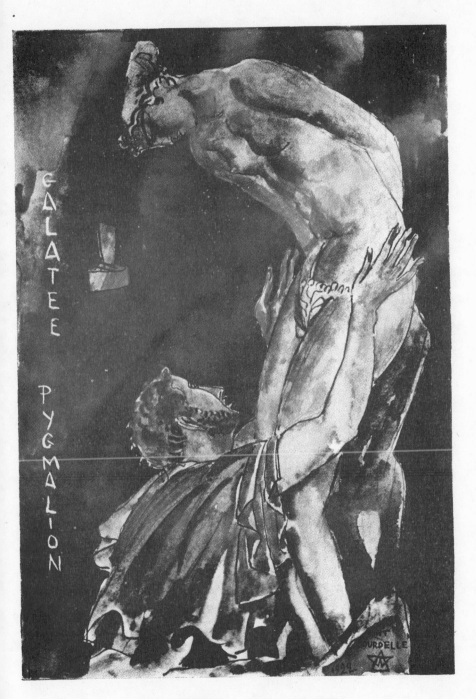

11. PYGMALION AND GALATEA

*sketch by Bourdelle*

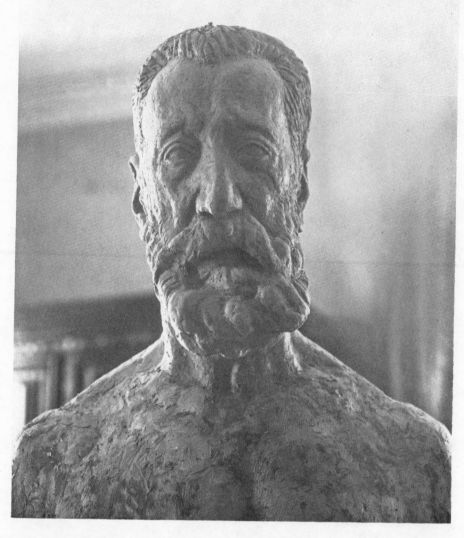

12. ANATOLE FRANCE
*by Bourdelle*

No other modern portrait can surpass this in perfect characterization. It shows Anatole France as we know him from his own pen. It might be taken as the perfect instance to show the superiority of art over photography !

The bust is in the Luxembourg Gallery and was made in 1919.

Maillol is distinguished from other sculptors by the ease and simplicity with which he treats the female form. This figure, in bronze, is typical of his best work. The absence of strain or effort and the simple attitude of the figure come as a relief after the nervousness and strain of Rodin.

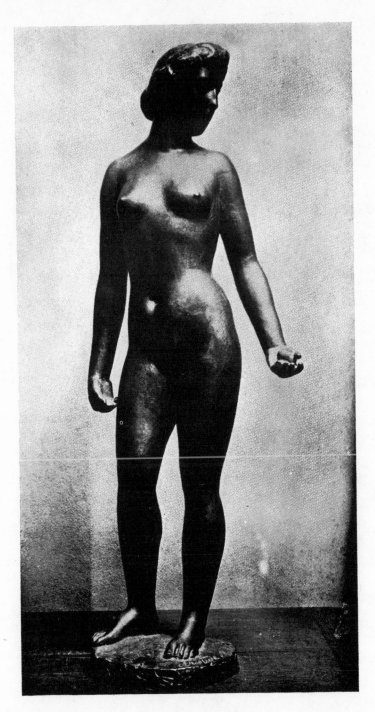

13. 'ÉTUDE DE NU'
*by Maillol*

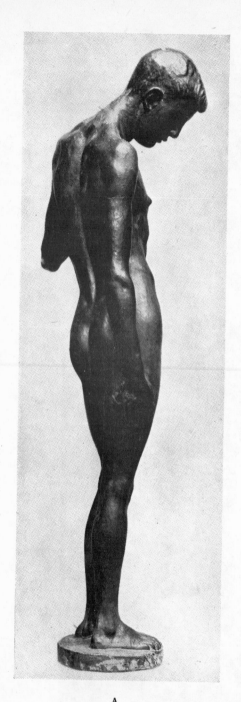
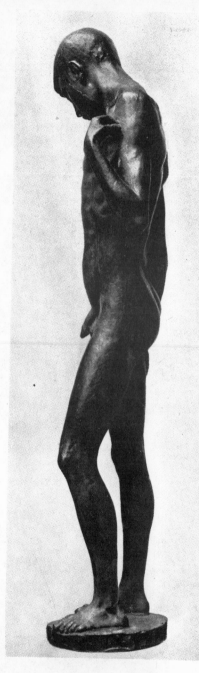

A                                                          B

14. 'YOUNG RUNNER'
*by Maillol*

In this bronze of a youthful athlete Maillol is less formal than usual. The figure is like that of a young Olympian victor. It is a perfect study of the human figure.

The bronze is in the Luxembourg Gallery.

A comparison of this version of 'La Pensée' with that of Rodin (Fig. 7) shows at a glance the difference between the two sculptors. Where Rodin is didactic, Maillol is expressive. Where Rodin explains in full detail, Maillol makes clear with a single gesture.

Two periods of art are crystallized in these two figures.

This figure was executed in terra-cotta soon after 1900.

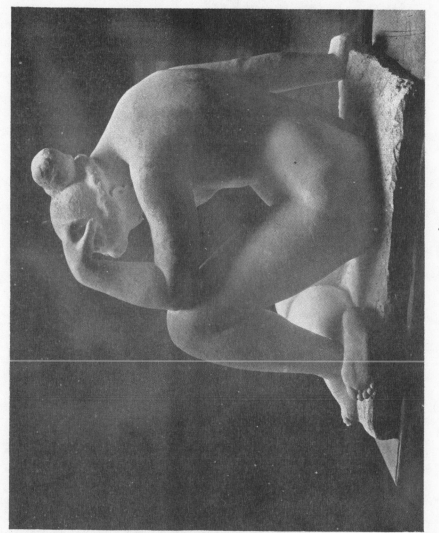

15. 'LA PENSÉE'
*by Maillol*

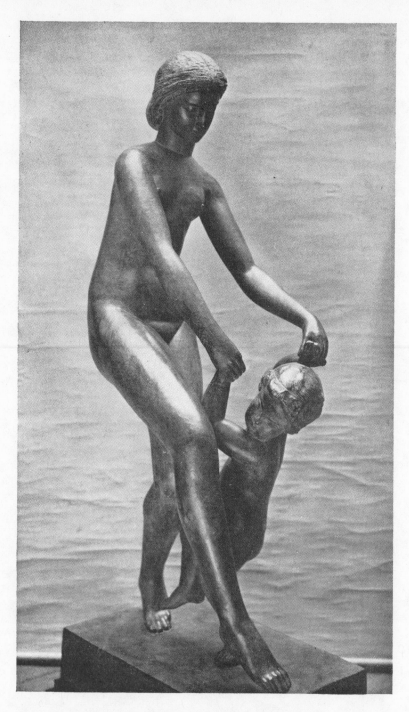

16. 'FEMME ET ENFANT DANSANT'
*by Bernard*

DESCRIPTION OF FIG. 16

Bernard is more formal than Maillol and less conventional. This
charming group, in gilt-bronze, achieves its harmonious com-
position by a careful parallelism of lines, within a fixed framework.
It can rank as one of the finest of Bernard's works. It is in the
Luxembourg Gallery.

A NEW MOVEMENT IN SCULPTURE

## Meštrović and Rosandić

IN 1911 the genius of Meštrović first made itself manifest to the world of art. The International Exhibition at Rome in that year showed the work of a master-mind, at once more impressive than the art of Rodin because it was more expressive, sim pler even than that of Maillol, and more pro- lific both in invention and in production than that of either. Here was a prodigy and a wonder in sculpture.

The London exhibition of his work in 1915 brought his work into even closer contact with the world in general, more especially as the particular appeal at that time of a South Slavonic artist gained for him a serious consideration and the rancour of outraged academics was less able, for purely sentimental reasons, to give voice to its customary outcry. He was accepted almost at once as a wholly new force in sculpture, as a worker in stone and marble whose facility knew no limits. To no one was Vasari's dictum more applicable that a sculptor sees in his block of marble the form that has already grown in his mind: and that his work thereafter consists only in removing from that block the superfluous material that intervenes between his hand and the achievement in solid form of that idea. The im- mense vigour of his work amazed by its facility of execu- tion, and by the ease with which even the most intractable of stones softened its angles in his hands.

A shepherd of peasant stock born in a remote village in

Dalmatia in 1883, Meštrović absorbed the very spirit of his land. To live amid rock seems to mould the spirit to a hard and unbending will. Every work of Meštrović is as instinct with the hard light of a rocky wilderness as are the soft lines of Florentine sculpture with that of the gentle pastures and valleys of Tuscany. A world eager for war saw his début; the turmoil of war saw his masterpieces; the satiety of carnage has acclaimed the bitter realities and stern emotions of his later work.

Balkan to the core, yet Meštrović is neither propagandist nor trumpeter. The innate Byzantinism of his land has moulded his taste into simple and controlled lines. His study at Vienna introduced him to the severity of Greek sculpture, of which his natural formalism led him to choose as guides the works of the severe archaic age.

His early life is a romance which has been rightly compared to that of Giotto. From being a penniless shepherd in the hills he became a mason's assistant at Spalato. A year later at the age of sixteen he worked at Vienna, opposed and unrecognized except by the few who saw his genius. At Vienna he made the acquaintance of Rodin, before Rodin was near the summit of his fame, and later in Paris fell under the influence of the then recently discovered sculptures of Delphi.

Vienna was his chief school. Visits to Italy gave him experience. But he always had an instinctive dislike of Renaissance art, which is hardly surprising in a nature which has been moulded in the traditions of a Byzantine world, to whom the elaborate splendours of Trau and Sebenico were repugnant, whose real taste had been formed

in the Orthodox churches and monasteries of lower Dalmatia.

His debt to archaic Greece is a large one. The formalism of drapery, the conventions of hair, and the rigidity of figure and feature that are seen in his Caryatids of the Kossovo monument is adaptation, not borrowing. It is as Hellenic as it is Byzantine. But his treatment of bodies shows the full anatomical knowledge of later ages.

His style is not uniform. He varies between extreme formality and what might be called 'formal realism'. But he is never purely realistic, however near he may get to realism. His Canadian War Memorial (Fig. 17) combines realism of attitude and equipment with a formalism so rigid that it is almost exaggerated. He has adopted the Greek system of superimposed planes, but where the Greek hardly ever employed more than five or six he has superimposed twenty-four in a way which, in some respects, recalls the frieze of the Cnidian or of the Sicyonian Treasures (Fig. 18) at Delphi, but which certainly exceeds the limits of the method. The Memorial is an experiment in old technique for a new purpose. He has wished to express the relentless discipline of war and its cold mechanism: he has adopted what is, in essence and origin, a mechanical method and worked it out to its logical conclusion. In doing so he has almost stepped outside the world of art, but he has achieved a rhythm and a repetition which are inherent in the subject which he has depicted.

Again, in the portrait of his mother, or in that of Mme. Banaz (Figs. 19, 20), he gives us a figure as serene as any Greek archaic maiden, yet with the essence of portraiture in

the face. Throughout he strikes an intermediate note between formalism and realism, separating them harshly at times, but always achieving their fusion in the end. No work of his is overbalanced on the one side or the other.

But before any consideration in detail of his works is possible we must realize that Meštrović is the only sculptor of modern times whose genesis owes little or nothing to prevailing tendencies in art or to the work of other masters. He is at heart the product of a natural setting and its latent traditions and the child of that strange amalgam of heroism and barbarism which is the spirit of the Balkans and their westward extension to the Adriatic. His equestrian statue of Kraljević Marko is the embodiment of the medieval heroism of the Slav lands of the south. His 'Serge' is a Balkan hero as typical of the living as of the dead. The type of face in his statues of this series is Balkan and Slavonic to a detail. The hard bony outlines, the thin determined lips, the massive jaw and low forehead give us the type of the Haiduk or the Palikari, the typical bandit hero of the Balkan ranges. Serb or Croat or Montenegrin mountaineers have the very passion and ardour that infuses the types which he sculptures. He is at the opposite end of the scale to Maillol. There is little or no Hellenism in his types; he gives us almost the apotheosis of the barbarian. He has seen and seized the quasi-nobility of the freedom-loving Balkan peasant and stressed its visionary qualities. The 'Maiden of Kossovo', 'Mother and child', and 'A Widow' show the powerful and independent womanhood of the Slavonic highlands. At any Montenegrin village you will see this particular facial type: in the Great War the Monte-

negrin women fought by the side of their men-folk and were seldom out of the sound of battle. Meštrović has given a new type to art with a power and a directness that Rodin never achieved. He has made the barbarian both intelligible and noble: in ancient art the barbarian was hardly ever more than a pathetic or a brutal curiosity. Instead of searching among ideas of the past for inspiration or reinterpreting 'impressionism' or 'classicism', he has with complete simplicity expressed that strange and clamorous feeling for freedom and self-expression that is latent in all the intensely virile Slavs of the south. Emotion as such he hardly gives us, only emotion in action or its effects. Whatever emotions there may be are given chiefly to the spectator.

An absolute independence of contemporary art often leads to erratic performance or to absorption in a mistaken idea or line of development. Meštrović has none of these failings for he has no conscious prepossessions. He makes no attempt either to get clear away from or to get into the varying currents of modern art. He has several widely divergent points of view. Thus there is his 'Heroic' style which gives us the whole of the Balkan saga. His religious work gives us that personal Byzantinism which is his peculiar power: it is the essence of a cold and formalized art that lives outside this world and so, by the medium of mere technique, achieves its religious aim, while Baroque or Renaissance religious art has to use human forms as symbols of another world. His 'Madonna and Child' and 'Crucifix' have unknowingly the mannerisms of Byzantine sculpture of the tenth and eleventh centuries, but a system of proportions and relations and a mode of composition which is

personal to the artist and which is neither wholly realistic nor wholly formal. In every formal work that he has achieved Meštrović has mastered the most difficult of all methods— that of building, whether in relief or in the round, upon a basis of planes, of making his figure grow from the stone not in a progression of ridges, of projections, and of un- equal curves, but in methodical planes and in modified rectangular forms. Here he stands in acute contrast with Rodin, whose figures break and billow from their stone matrix into such violent life as he gives them. But Rodin was in technique chiefly a modeller: he built up rather than cast off. Meštrović casts off from his square-hewn block the parts of it that encumber his conception of what lies within. Unconsciously his hand is controlled by the stone; its planes and angles appeal to his eye; he is influenced by his material and by the natural cleavages of stone. He seems to work as works sometimes the unseen sculptor of Nature who achieved those occasional cliff-sculptures that resem- ble works of art, by the slow processes of frost and attrition, that sculptor of Nature who taught the Hittite to improve on his work on cliff-faces and projecting outcrops. Rodin actually or in imagination builds up in clay and translates into stone and in so doing is, for good or evil, not under the control of his material.

The summit of Meštrović's achievement is a work which shows all his styles and all his capacities harmonized in and working for one end. This achievement is in an architectural setting of the artist's own composition and in natural sur- roundings that go far to enhance its magnificence. In 1920 he was commissioned to build a memorial mausoleum to

the old Croatian family of Racić, by their last surviving relative. The site chosen was one of the most magnificent in the Mediterranean: it stands upon the summit of a cypress-covered promontory at Cavtat, or Ragusa Vecchia, on the acropolis hill of the ancient Epitaurum, a half-Hellenic, half-Illyrian city. In 1922 the monument was complete—an amazingly short time for such a work (Fig. 21).

The mausoleum is in the form of an octagonal chapel of the utmost simplicity. It is composed of the white crystalline marble of the island of Brać, a source abandoned and forgotten since Diocletian used it for his palace that lies on the mainland opposite. The chapel stands out on this lonely promontory high above the quiet town (whose name preserves the Latin Civitas) and it is surrounded by an amphitheatre of towering cliffs that bear down upon it with their massive weight. From the sea the chapel rises clear from the cluster of trees that surrounds it, crowning the hill. In general appearance it recalls the Tomb of Theodoric at Ravenna on the Italian coast.

The building as a whole reflects the powerful influence which the discoveries at Delphi have had upon the sculptor. He has consciously followed in the tradition of the chapel-like Treasuries, of which that of Cnidos seems here to be the particular prototype. Hellenic archaism is the evident inspiration. Two caryatids in angelic form with arms crossed on their breasts support a gable which is decorated with a perfectly proportioned palmette design in relief. The octagonal cornice of the octagonal roof is rendered as a frieze of highly stylized winged beasts in pairs facing and cut in two planes. Upon the roof, which is made

in steps, is a guardian angel in bronze surmounting the cupola.

In the interior there is one principal chapel and two subsidiary, each projecting from the sides of the building to an equal distance and so providing architecturally a buttressing to the lateral thrust of the walls. The principal chapel contains a sculpture of the Virgin and Child over the altar (Fig. 22), while that on the left contains the Christ crucified and the chapel on the right a figure of a local saint, St. Rochus, with his dog at his feet. Three low steps lead into each chapel. The floor of the building is composed of inlaid marbles of varied colours forming a great rosette with subsidiary designs. This inlay is a peculiarly Dalmatian art of very long standing, but here is the most recent and one of the finest examples of it.

The main chapel shows a simple figure of the Virgin holding the Child upon her knee. She faces the spectator directly and is seated. Her figure is rendered in the most formal way and draped in the Byzantine manner. Beneath her feet is a footstool upon the front of which is an enhaloed Lamb in low relief in one plane, almost heraldic in its simplicity. The side walls of the chapel slant outwards and contain each three figures of a holy choir, winged youths playing musical instruments. The skill with which the figures are differentiated without their pose or shapes being violently contrasted is testimony to the artist's ability to vary in detail within a close convention. The figure playing the violin is of peculiar charm.

Below the footstool and supporting the whole is a large plaque in relief showing the Descent from the Cross: it is

an astonishing composition and can rank among the finest reliefs that the artist has executed. The ceiling of the main chapel and of the two subsidiary chapels is a gable roof and is decorated with panels about two feet square, some containing inset reliefs of cherubs' heads with folded wings and others pairs of holy doves. These panels are perhaps the most closely Byzantine of all the sculptures.

The altar and chapel of St. Rochus (Fig. 23) are even more simple and severe than the main chapel. The figure of the saint projects from the wall on a small pedestal. On each side is a white marble candlestick upon a bracket the lower part of which is adorned with an angelic head of sombre expression (Fig. 24). The saint is shown in robes reaching to his feet and with a pilgrim gourd-bottle at his waist. His face is the strange ascetic type that Meštrović can render so well, his figure tall and lean, with robes whose folds harmonize with extreme simplicity into the general balance of the figure.

On each side of the chapel is a relief of a member of the family of Racić. The modern costume in which they are shown makes no contrast and no discord in the general style of the building. All differences of subject and treatment are harmonized in the unity which the personality and power of the artist achieves, whether they are Byzantine, Hellenic, or modern.

The chapel in which is the Christ crucified gives us one of the finest religious sculptures from the hand of the artist. There is no other adornment except for two candlesticks as in the other chapel and two more portrait reliefs of the family. The Christ is simple and strictly formal, the body

being cruciform. The light here, as in the other chapels, enters from two side windows and is, in addition, reflected up from the centre of the building where it is generally diffused. Each chapel is thus both a centre of reception as well as of distribution of light. The entrance of the light from the side in some strength serves admirably to emphasize the surface moulding and the linear forms of the drapery of the figures. It is not the least of the structural details which go so far to enhance the beauty of the sculptures as well as that of the building as a whole.

Between the chapels and facing the entrance, on the two sides of the octagon which rise between the main Chapel of the Virgin and its two side chapels, there stand high above the spectator in full relief, or almost in the round, against the wall two great angelic figures (Fig. 25 and Frontispiece) carrying in their arms the souls of the dead, rendered, as in early Greek sculpture, as diminutive forms. The little souls rest in the arms of the two angels; one is praying. These solemn and splendid figures are the most impressive that the artist has achieved. Each has two pairs of wings, one large and folded downwards behind the shoulders, the other smaller and crossed behind the head in the manner of the cherubs' wings in the dome of St. Sophia. The figures are so poised as to seem to be rising upwards in swift movement. In the dome above, which hangs over them like the sky, are set at wide spaces angelic faces inset in panels, and the top of the octagonal dome is surmounted by a cupola from which is spread from windows that are invisible from below all the light that enters the building by ways other than the chapel side-windows. In this bright well of light

hangs the one great bell, itself bearing delicate reliefs on the bronze.

The whole building is a perfect harmony of architecture and sculpture, of symbol and fact, of legend and history, of conventionalism and originality. Here are contained the record of the dedicating family, the story of the local saint, the history of the Crucifixion, the symbolic figure of the Virgin and Child, the mysterious carriers of souls who rise into the domed heaven, and with them the conventional symbols of the Dove and the Lamb and the Angelic Choir. There is no hint of creed or of any special type of Christianity. The building is simply religious and simply Christian. No special sect could claim it as its own.

Behind its Christian aspect lies the older and more venerable aspect of its nature as a monument of memory. It preserves for all time the memory of a family, as the hero-shrine of ancient Greece preserved that of a dead hero. It is no mere Egyptian Mastaba where the dead lived and were conversed with. Nor is it a mere mausoleum for the formal preservation of names and bodies. It is a monument that challenges the ages not to remember this or that particular family by face and by name and by their devotion, but to remember that the family to whom it was erected was consecrated to Time by the most devoted work that any master artist could be called upon to execute. Here he combined all that sculpture, architecture, and symbolism could combine in one place, and in this place it stands for all men to see and wonder at until the passage of years shall have reduced it to dust. And this shall not take place until the very nations who lived to see its building have them-

selves passed away as well, for the memorial is in stone, and memories enshrined in stone long outlive those with whom they are concerned and those who kept them even for generations after. This memorial is the artist's greatest achievement and his most deeply considered work.

I have described this building in some detail because an understanding of it, of its subtle arrangements of structure and decoration, its harmonizing of startling detail with impressive whole, and its intellectual thoroughness give us no inconsiderable clue to the creative power of its author. No detail is scamped, no opportunity of perfect finish avoided, and yet the last impression to be created is that the sculptor was frantic to fill every nook and cranny with subsidiary detail. The first and most lasting impression on the spectator as he enters is that the interior, like the exterior, is plain and simple almost to bareness. Closer inspection reveals that the wealth of detail is astonishing, that no opportunity has been missed, and that there is far more to admire than was thought at first sight. I know of no other modern monument where detail is so properly relegated to its proper place: it both serves its purpose of breaking monotony and satisfies other demands in being in itself admirable, and not merely dependent or subsidiary; while it never diverts the eye from the chief purpose and the chief masterpieces it never sinks to mere triviality. Nor in the detailed work do we see either the weakness or the strength of the master. Rodin could never achieve detail because it did not interest him: Barye often lost himself in its forest.

Meštrović is neither the first nor the oldest artist that

Dalmatia has produced in recent years. Thomas Rosandić, the sculptor, was born in 1878 at Spalato, the son, like so many sculptors, of a stoneworker. Meštrović, coming to Spalato to learn the trade of master-mason, met Rosandić there, and they learned much in common. Soon after, Rosandić went to Italy, where he went to Rome and Florence and finally spent two years studying at Venice. In 1906 he achieved his first statue and sent it on exhibition to Milan. He then returned to Spalato and worked closely with Meštrović, deeply influenced by his junior. For some time after this he worked alone and in 1912 held an exhibition at Belgrade. Many of his works were lost or destroyed during the war,[1] but in 1917 and in later years he exhibited in England, where he achieved no small success in London, Brighton, and Edinburgh.

His work is brilliant, but he is not a great sculptor. Sometimes he is profoundly under the influence of Meštrović, sometimes he is not. Yet at times he achieves a masterpiece, and it is difficult to avoid the conclusion that in a country that had not produced Meštrović he would have risen to a position of very great eminence. What strikes one at first is that he has so many styles that it is hard to detect which is his own. His reliefs are largely in wood and follow both the style and the technique of Meštrović: but they seem uninspired and more like exercises in the manner of Meštrović than original works. Some of his portraits, on the other hand, and some of his simple figures have an originality

[1] See *Galerie des artistes yougoslaves*, vol. 1 (Zagreb, 1920). Out of seventy-four works here catalogued eighteen were lost or destroyed during the war. See also J. R. Van Stuwe in *Elsevier's Maandschrift*, Sept. 1927, p. 161.

and a stamp of personality that is undeniable. 'La Pucelle' (Fig. 26), a statue in wood, if slightly mannered in style, is beautiful and simple. A torso (Fig. 27), also in wood, at South Kensington shows great power and firmness of treatment. Undeniably there is something in his work which is found also in that of Meštrović which is a common racial inheritance of both of them. It is not merely the interaction of one artist upon another. Where he fails to learn from Meštrović is in his treatment of drapery: he rarely contrives that perfect harmony of the lines of the drapery with the structure of the body which it covers.

He shows in general a much more marked influence from Rodin than does Meštrović, and some of his works are almost exclusively French. The two statues, however, just referred to exhibit his personal style more purely and clearly than any others and they show the best that he can do.

Perhaps in rivalry to Meštrović, perhaps because the nature of the country and the abundant material available make conditions for such experiments favourable, he has built on the little island of Brač a mausoleum comparable in its general conception to that at Cavtat. The architecture and the sculptural decoration are both from his hand. But the style is more conventional and is intended to be more national and less eclectic than that of the Meštrović memorial. The building stands above the sea on a headland and is a blend of Gothic and Slav Byzantine that is not pleasing. Its general outline and proportions are unsatisfactory and much of its decoration is inharmonious. But in detail there is much admirable work and the semi-

Gothic doorway (Fig. 28) is carved with an attractive and intricate design. The whole building lacks the principal virtue of the Cavtat chapel—simplicity. It gives at once an impression of overweighted ornament, of excess of care, and of too much detail. Yet it marks a proud ambition and suggests what indefatigable energy is to be found in Southern Slav artists. Here is an artist who willingly devotes himself to a labour of vast enterprise. There are no buildings comparable to these two chapels elsewhere in Europe, because other sculptors have not the same energy. They have for generations been brought up to believe that all a sculptor need do is to make a plaster or clay mould and leave the rest to his assistants. They all too frequently never touch with their hands the metal or stone which is the final material for the work of art. They are, all too often, artists at second-hand or even third-hand. They even allow mechanical reproductions of their principal work to be produced on a smaller scale and to let them pass as the work of their hands. To this inertia the experiments of Rosandić, successful or unsuccessful, must come as a corrective and an inspiration. He is one of the modern sculptors who are leading and not following. All sculptors who love the material they use, who bring it under their hands at every stage, and who issue nothing that is not the produce of their own personal activities can to-day be classed as leaders. The rest are but followers of an unworthy and almost forgotten fashion.

ILLUSTRATIONS TO CHAPTER III

There are few War Memorials as impressive as this. It is a simple and direct work of art, as simple and direct as war itself—at least war in the front line, where there are only two matters of importance, life and death. That is all that Meštrović has tried to express; he has omitted the glory, pomp, romance, and splendour of war because they are not usually found in the front line.

The relief was cut in 1918 and is in Canada.

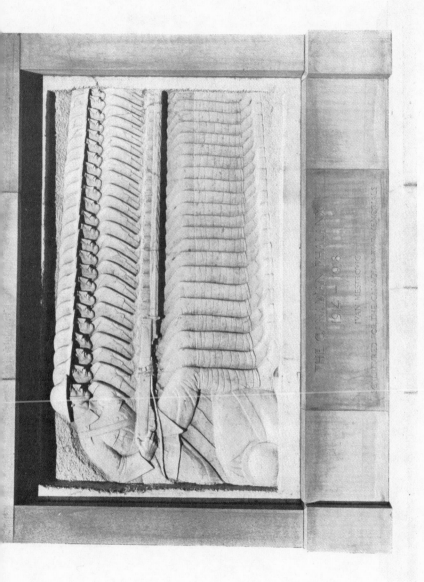

17. CANADIAN WAR MEMORIAL
by *Meštrović*

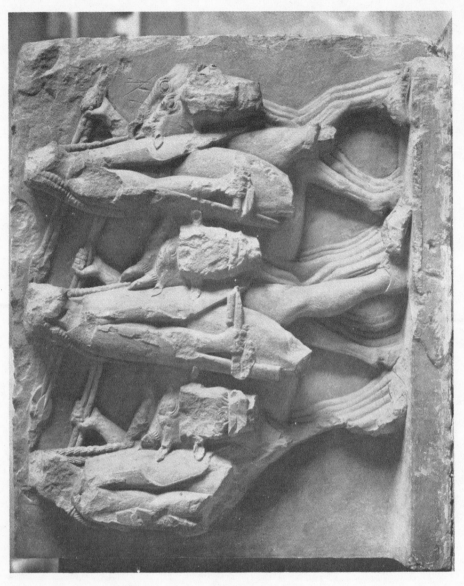

The technique of this Greek relief is identical with that of the Canadian monument. It shows three warriors returning from a raid, bringing the cattle of their enemies with them. While all three warriors seem identical in garb and attitude, yet there are subtle differences of detail which prevent the monotony which one finds so often in Egyptian art.

The formal repetition of lines creates a rhythm like that of a marching song. The clear distinction of planes here, as in the Canadian monument, catches the light and emphasizes the rhythm.

The relief is from the Treasury of Sicyon at Delphi and is sadly damaged. It belongs to the time 560–550 B.C. and is now in the Delphi Museum.

In this portrait of his mother the sculptor has combined the severe methods of the archaic period with a simple realism. It is an early work and was cut in 1908 at Split.

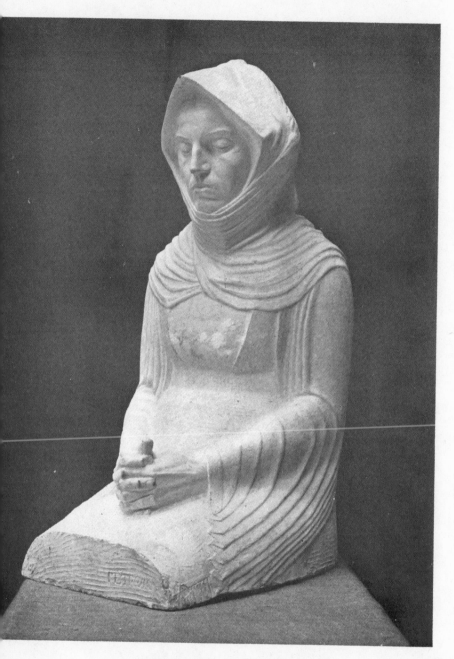

19. PORTRAIT OF HIS MOTHER
*by Meštrović*

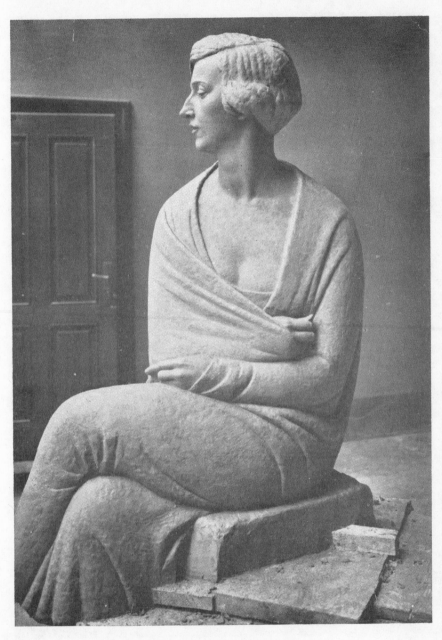

20. PORTRAIT OF MME. BANAZ

*by Meštrović*

There is only one possible point of view from which to look at this masterpiece, and that is from the point of view from which the photograph was taken. It is virtually a high relief. Yet who would call it a primitive work of art? The artist has merely adapted a simple method to a modern use. His treatment of the drapery is nowhere more successful than in this figure.

The portrait is in gilt bronze and is one of Meštrović's most recent works. It is in the possession of Mme. Banaz.

The monument of the Racić family at Cavtat stands in a cypress grove on the old acropolis of an ancient city above a land-locked bay near Ragusa.

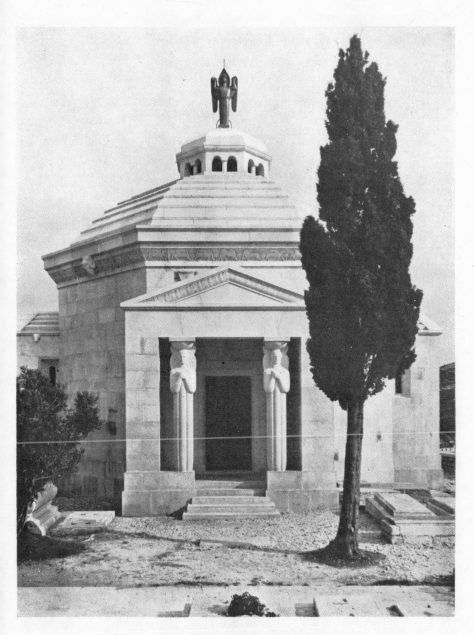

21. THE MONUMENT AT CAVTAT
*by Meštrović*

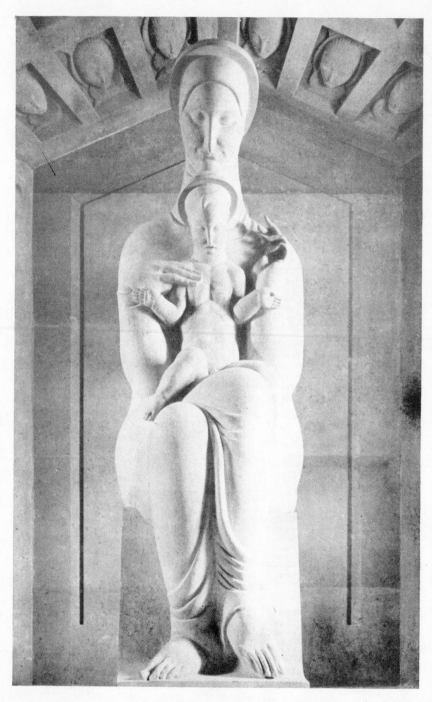

22. VIRGIN AND CHILD
*by Meštrović*

The Virgin and Child is the central group in the chapel. The artist's personal style is more evident here than in most of his work. The figure is life-size. It suggests comparison with twelfth-century Italian sculpture.

In the ceiling-panels is seen the choir of cherubs. On each side is a panel in relief (not visible here), and below the feet of the Virgin a pedestal also adorned with reliefs.

M

The lighting of this figure, which is really a high-relief, is from two sides and comes from the windows.

The subject is treated in the manner of archaic Attic reliefs. Again we can see how skilfully Meštrović has used the drapery to give dignity to the figure.

Throughout the surface is kept flat and nothing protrudes to break the evenness of the planes.

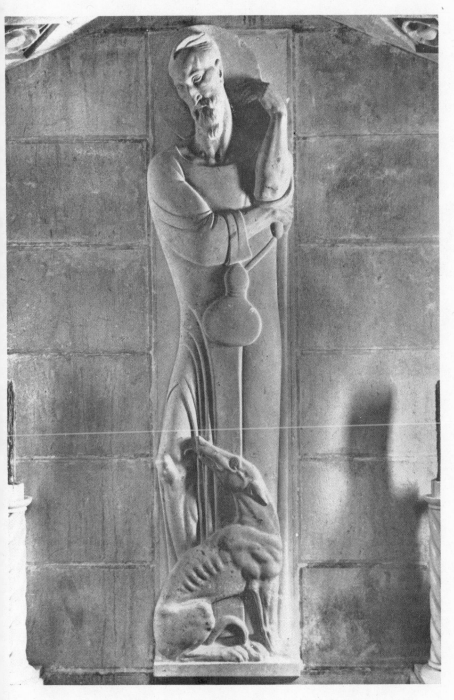

23. St. ROCHUS
*by Meštrović*

DESCRIPTION OF FIG. 24

These are quite small sculptures, the faces about half life-size. In this photograph the fine-grained surface of the Istrian shell-limestone is clearly seen. The dull polish takes soft shadows. The candlesticks on these brackets appear at the top of the plate. They are in white marble.

Both this and the figure shown in the Frontispiece may be considered as essentially architectural sculpture in contrast with the figures in the side-chapels.

The conception of these angels who carry away the souls of the dead is as ancient as that of the winged figures whose function is the same in the reliefs of the Harpy Tomb in the British Museum.

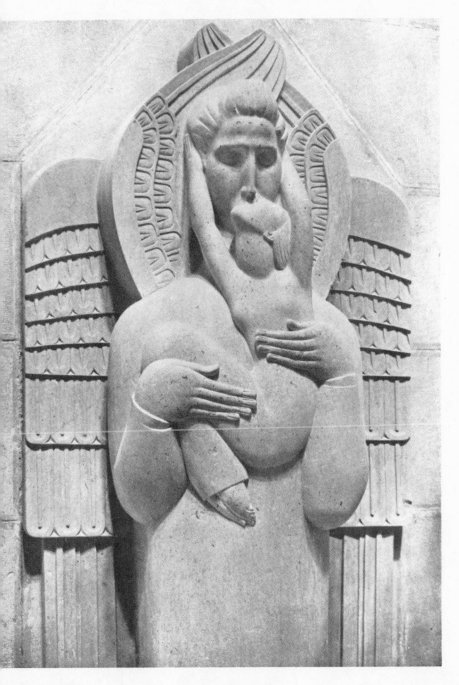

25. ANGEL
*by Meštrović*

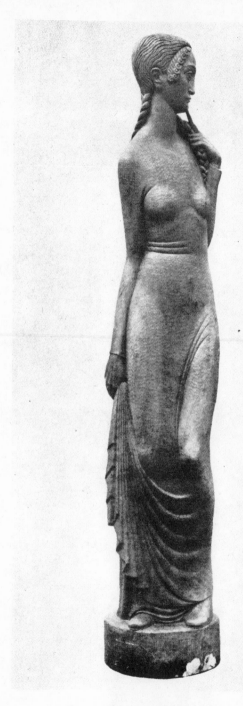

26. 'LA PUCELLE'
*by Rosandić*

## DESCRIPTION OF FIG. 26

This little figure in walnut wood, of life size, is, perhaps, the most charming of the works of Rosandić.

It is in private possession in London, and was exhibited at the Grafton Galleries in 1917 with other works of the sculptor.

It is called 'La Pucelle', or, alternatively, the 'Vestal Virgin'.

A torso in walnut wood, the property of Mr. F. M. S. Winand, and now exhibited on loan at the South Kensington Museum.

It is a little less than life-size. It is called by the artist 'Desire'.

Here, as well as in 'La Pucelle', the artist is seen at his best, working uninfluenced by others. In the hands of Rodin the subject would have been treated with more violence and less simplicity.

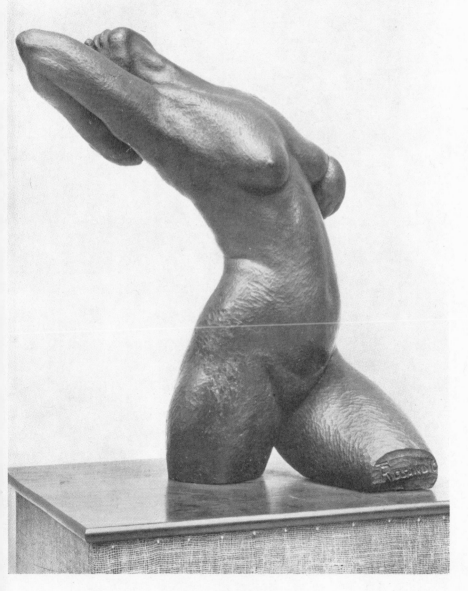

27. TORSO

*by Rosandić*

28. DOOR OF MONUMENT ON THE ISLAND OF BRAČ
*by Rosandić*

The main gateway of the Mausoleum of the Petrinović family on the island of Brač.

The building, architecturally, is less satisfactory than its sculptures. The artist, however, seems to hesitate between the Renaissance and the Middle Ages in his sculpture and the result is confusing.

This doorway is, perhaps, the most decorative part of the building.

## ERIC GILL AND GAUDIER-BRZESKA

### *Two Independents.*

THE work of Eric Gill is, in essential character, English. He is neither an inventor nor an innovator, and he falls into a wholly different category from that into which any other modern sculptors may be put, in so far as he attempts consciously and deliberately to base his artistic impulses upon religious instinct. Unlike most artists he has published his creed in writing and made a valiant attempt to give a full and coherent exposition of how his religious views control his art. In effect his creed is a blend of pure Roman Catholicism and Guild Socialism. Like many artists who have ventured upon an exposition of their theories he suffers at times from obscurity of expression, if not of thought. His constant reference to religion blurs the rather faint outlines of his aesthetic, and the aesthetic itself upon examination proves to be little more than an appeal to sculptors to work directly upon their material and not through the medium of clay or plaster, so that they may avoid the confusion of the technique of two different mediums. To this appeal he adds a warning that carvers in stone must have in their minds before they begin a complete and perfect knowledge of the forms they desire to create. His theory—it can hardly be called an aesthetic—amounts to no more than this. But it would be better to give his own words.[1]

[1] *Sculpture: an Essay on stone-cutting* (St. Dominic's Press, n.d.), pp. 22 ff.

'What is important is what the workman has in his mind, not what some model has in his body. This is the attitude of mind of all great periods of sculpture.' 'Modelling in clay . . . is a process of addition; whereas carving is a process of subtraction.' The proper modelling of clay results in a detachment of parts and a freedom of attitude. But a clay model is no guide for a stone statue. 'The sort of thing which can be easily and suitably constructed in clay may not be and generally is not suitable for carving in stone: . . . the finished work is not a piece of carving but a stone imitation of a clay model.'

His explanations are simple and clear but not original. Vasari, in the passage already referred to (p. 59), has told us the function of the sculptor perhaps more clearly. Rodin, Meštrović, and all the great sculptors have avoided clay models for the reasons given by Gill, which were to them commonplaces.

The value of Gill's work does not lie in the exposition of its theories but in certain qualities of a very high order which are not found in the work of other recent and contemporary sculptors. He has, in the first place, a profound feeling for the decorative values of the human form. His knowledge of these values is the same as that which the Anglo-Saxon sculptors possessed in the ninth and tenth centuries of our era. Gill's 'Adam and Eve' is a design the elements of which are human bodies. The unity of the design suits the subject: he has all the facility of the artist of the Book of Kells in interweaving human and formal elements. His Madonnas have the formal quality seen in the Langford Rood (Fig. 29), as have also many of his

crucifixes. But at the same time his search for formality keeps from him a full knowledge of the inter-relation of the masses which make up the structure of the human form. He is rarely a good sculptor of figures that are completely in the round. His isolated figures are so often like figures that have been sliced off from reliefs: usually they are constructed to be seen from the front or from the back but have no side aspect at all—they are, in fact, little more than 'biscuit' sculpture.

Conceivably Gill's predilection for flat work, often only in two very simple planes, is due to his early training. He started work as a carver of letters, a pursuit which he has never abandoned. One of his most magnificent achievements in letter-cutting is the great war memorial, containing over three hundred names, on the wall of the ante-chapel of New College, Oxford. The absorption in design upon a flat surface has dominated the whole of his sculptural work so that his masterpieces are to be found really in relief. His Stations of the Cross in Westminster Cathedral and his war memorial at Leeds of the 'Cleansing of the Temple' show what is at no point more elaborate than the simplest possible conception of relief-carving. His draped figures in relief rarely show such skilful manipulation of drapery as to indicate the human forms that lie beneath; they tend to look solid and stocky, and in this respect his work falls far short of that of the old Anglo-Saxon sculptors, as a glance at the Langford Rood will show. But a recent work, a magnificent stele (Fig. 30) carved on both sides, has caught the Anglo-Saxon spirit to the full and adapted it to a perfect composition. This relief is satisfactory in every sense and

is a profound contribution to the masterpieces of relief. It has none of the faults of the Stations of the Cross and is a perfect example of two-plane relief.

But his magnificent torso in Hoptonwood stone, called 'Mankind' (Fig. 32 A, B), places him definitely in the ranks of sculptors who can, if they wish, carve figures in the round, and carve them magnificently. The beauty of this great torso, for it is of colossal size, lies principally in the absolute simplicity of its surface. The bodily structure in this figure is quite perfectly understood and perfectly expressed: the bodily surfaces are moulded with an infinite care and sympathy. And yet the figure is no Galatea. It is so firmly conceived in the world of art that there is not the faintest suggestion that it will come unexpectedly to life with the simper of a Venus Callipygos. It is formal art that is not unreal; above all it is art. There is much, no doubt, in the torso that is omitted if it is to be considered as a correct anatomical study. It is a human form reduced to its principal and most fundamental forms and relations. Its beauty is enhanced by the magnificent block of stone from which it is cut, which is finished with a perfect surface.

Equally successful in a different way is his curiously archaic mask called 'Susan' (Fig. 31). In this we can see particularly clearly how much use he makes of the formal lines of the hair. This is evident in many of his works. Where Meštrović employs the beauty of drapery as a foil to the human form, Gill uses the hair. It gives a setting to a face or to a whole figure. In this particular head the face is framed in a setting of hair that is made into pure design. Sometimes he paints the hair and so emphasizes this effect.

One is reminded of the floating locks that enframe the great Romano-British head of a sun-god from the baths at Bath. There is something both in the 'Susan' and in many of Gill's faces that seems rooted in the artistic traditions of England, whether British or Saxon.

From both these last works it is possible to conclude that Gill can, if he wishes, work with success in the round, but that his preferences are for relief. In both he shows the qualities of a great sculptor.

What seems of great importance in Gill's work is his economy of ornament and his perception of the decorative value of adjuncts. His work is never laboured or fussy; he uses the lines of drapery with the highest decorative value even if he fails to co-ordinate them with the bodily lines beneath them.

In essence, Gill is a Byzantinist, just as his Anglo-Saxon prototype was. He has not consciously copied antiquity at any point, but he has formalized his compositions as a Byzantine formalized them, and he has introduced into his figures a quality of face and form which is as English as the faces and forms of the Northampton alabaster carvings of the thirteenth and early fourteenth centuries. He is a true western Byzantine, controlled by the native style and manner of British art.

The religious basis of his art serves more as a limitation than as an inspiration. His concentration upon religious subjects leads to a certain sterility of ideas. Just as Botticelli achieves complete fullness of beauty in his 'Birth of Venus' and similar works, so Gill approaches greatness when his work is unfettered by traditional religion. His 'Dancer'

shows a fine conception of movement and is a figure of considerable charm and beauty. His torso of 'Mankind' is a superb and profound work, entirely unreligious.

His best work is still to come, for he is a young man. His great value, as in the case of Meštrović, lies in his complete independence from any recognized line of development. Even Meštrović is touched by the style of Rodin in some rare instances. Gill might never have heard of Rodin for all that his sculptures show. He is one of the very few sculptors whose work is untouched by the French school: like that of Meštrović it has its roots deep in the national life of the country of his origin.

Unlike most modern sculptors Gill has done a certain number of definitely bad works. It is as well to distinguish them in order that his reputation may not rest upon judgements made upon them. His 'Crucifix' in the Tate Gallery can hardly be taken seriously at all. It is an atrocity. Gill does not take it seriously himself. The inscription alone gives it artistic value. The figure of Christ is formal without any of the dignity of formalism and uncouth without the interest of uncouthness. In it we can detect a mediocrity which he has now successfully evaded.

Of young modern sculptors none ever showed more promise than Gaudier-Brzeska. He was born in France in 1891. Like Bourdelle he was the son of a woodworker—a craft which led him directly to sculpture in stone. At the age of fourteen he went to England, where his promise was recognized. He worked at Bristol, where funds were procured for him, and thence he went to Germany. He can be classed

more as an Englishman than a Frenchman because most of his early life was passed in this country and most of his sympathies were on this side of the Channel. In Germany he worked and travelled, often almost penniless, and in 1910 started to work seriously at Paris. Later he varied a life of poverty between London and France. In August 1914 he went from England to France to offer his services in the war. He was arrested at Boulogne as a deserter because he had never done his military service. He escaped and returned to London, where he made arrangements with his Embassy to be taken for active service. In June 1915 he was shot through the head at Neuville St. Vaast, leading a charge, at the age of twenty-three.

His period of greatest intellectual and artistic activity was from 1911 to 1914. In this time he formed one of a small group of artists who attempted to launch in magniloquent but vague terms the short-lived movement known as 'Vorticism'. Had he not thrown in his lot so definitely with this group, many of whom were utterly third-rate artists and writers, he might have produced far more works of a high order. As it was, much of his abounding energy was frittered away in futile manifestoes that were manifest to no one and that no one read. Irrespective of the worth or worthlessness of the Vorticist creed, the industry and spirit that underlay Gaudier's work was astonishing. He had the makings of a very great sculptor and a charm and vigour of personality that stamp both his line drawing and his sculpture with the mark of greatness. His occasional publications, which usually appeared in ephemeral art-journals published in Paris, give us many hints of his intelligence if we have the

patience to thread our way through the conventional jargon of the 'Quartier' of those days. 'I shall derive my emotions', he wrote from the trenches in1914,[1] 'solely from the arrangement of surfaces, the planes and the lines by which they are defined.' This is clarity and simplicity and of no little value as coming from the lips of a sculptor. 'Line is a thing purely imaginary: it comes into the composition merely to define the outlines of a mass. . . . The artist who searches for pure line and adjusts his outlines to it is wrong, for he adjusts a picture to a frame and not a frame to a picture. That is why I hate Ingres, Flaxman, and the pre-Raphaelites and all modern sculptors except Dalou, Carpeaux, Rodin, Bourdelle, and some others.'

He fell, as can be gathered from the above remarks, under the influence of Rodin, which then still controlled the studios of Paris. Gaudier's earliest work is said to have been in the Rodin manner.[2] He drew many of his best line drawings, unconsciously following Barye, in zoological gardens. The swiftness and precision of his animal drawings are so close to those of Barye as to be at times almost indistinguishable. But he was a tireless experimenter. He soon saw that there was a certain value in the strange outpourings of the Vorticists, a small but quite appreciable residuum of sense, that inorganic forms may often have as much beauty as organic—itself a mouselike truism that hardly justified the mountainous labours that begat it. He experimented in pure inorganic forms in sculpture and produced some work that

[1] *Gaudier-Brzeska: a Memoir*, by Ezra Pound (Lane, 1916), pp. 20, 26, 43. This publication does scant justice to the artist's merits. All quotations of statements by Gaudier are taken from it.

[2] Ibid., p. 51.

has definite value and interest in this connexion. But his most successful achievement was the rendering of natural organic figures with a sense of inorganic pattern added to them. He never went quite to the lengths to which Brancousi, Modigliani, Zadkine, and Archipenko have gone, whose 'pure forms' are often but patterns disguised as organic figures (Fig. 33). He had, too, a profound sense of the superior value of organic form, of the living and moving body. His animal drawings in silhouette are inspired by a study, which he often openly admits, of Palaeolithic paintings, a source which never fails to stir the sentiment as well as the sentimentality of the French. He never gave himself over unreservedly to the side of 'pure form' or 'inorganic' form, for he realized that this was a subject for experiment rather by painters. He could not easily side with a creed that manufactured an artist with ease. 'The sculpture I admire', he said, 'is the work of master craftsmen. Every inch of the surface is won at the point of the chisel, every stroke of the hammer is a physical and mental effort.' He avoided tradition, which he called the 'Rodin-Maillol mixture', and he thought for himself. And when he thought for himself it was always in terms of his material. He was, as is obvious, a sculptor who worked direct upon the stone.

Another statement of Gaudier's deserves attention. 'Sculptural feeling is the appreciation of masses in relation: sculptural ability is the defining of these masses by planes.' This and the first statement of Gaudier's here quoted are, as the words of artists nearly always are, more pontifical than the subject deserves. But what emerges is clear enough, and, as Gaudier puts it, brief and simple. The

sculptor must aim at a harmony of planes and not a violent contrast, and the planes must be part of, so as to define, the various masses that make up the sculpture. Or, more simply, there must be a proper balance and proportion in the figure and a system of planes underlying it—the archaic Greek system and nothing more. If a mass projects from one part of the sculpture out of all relation to it, it violates the harmony of the whole and cannot be fitted into the imaginary or actual system of planes upon which the figure is built up. The archaic statues of early Attica are built up upon a system of rectangular planes so that each whole figure fits into a square. If one arm had projected forwards and one leg outwards the plane would have been broken and the imaginary geometrical figure into which a statue could fit would be spherical or spheroidal. 'Defining masses by planes' is another way of saying that a figure must be made to fit into a rectangular or angular system. This is particularly evident in the finest sculpture which he executed —'The Dancer' (Fig. 34), of which the original is in South Kensington. Here the planes are more subtle but none the less obvious when found. The body is in a vertical rectangle and the arms and legs extend from it in two triangular arrangements. There is no torsion and no confusion of curves: the statue is archaic in its simplicity. 'The Singer' is even more so and wholly rectangular. Gaudier was in the archaic period of art—whether Greek, Gothic, or Chinese hardly matters. But he got the fullest advantage out of this archaism and rigidly avoided the complete or too complete torsions that Rodin thought were the fullest development of which the art of sculpture was capable.

In his treatment of surfaces Gaudier showed a simplicity and understanding that have not been excelled by any modern artist. His torso in white marble (Fig. 35) at South Kensington, like the body of the Dancer, shows an exquisite understanding of surface moulding as well as of bodily structure. It is a coherent body, not an aggregation of parts of a body. The proportions, too, are perfectly contrived.

In his interpretation of movement he really achieves a new style in modern sculpture. The 'Dancer' is a figure in which movement is detected rather than seen, and detected at a moment when it is neither static nor in motion, when it is potential and yet not stopped. No sculptor, to my knowledge, has ever depicted a figure thus *descending* out of one movement into another. Rodin's definition of movement as 'transition' is here carried out more clearly than he could ever have wished and more effectively than he could ever have achieved. There is no representation of motion here, only its full and direct expression.

Gaudier's little bronze figure of a 'Fawn' (Fig. 36) shows the artist in a different light. Here he is attempting with affection a living form which has a particular charm and oddity. The 'legginess' and gawkiness of the young beast is what clearly attracted him most. Its odd limbs formed an odd design. The figure that results gives us a conception of animal-sculpture that is wholly refreshing and which appeals directly to our gentler and more humorous emotions. He has done other animal sculptures in the same vein, always with an eye for design and for a graceful grouping of masses.

If Gaudier had not fallen into bad hands, as it were, and absorbed so much of his energy in manifestoes and experiments in Vorticist sculpture he might have left us far more than he has in fact done. His few brief years of production were fertile enough, and even if he had done the 'Dancer' and the 'Torso' alone he would have made two unforgettable contributions to the advancement of art. His loss is one of the most serious in art that the war caused. He had the true sculptural feeling. Every drawing that he did, and some few survive, is instinct with a feeling of solid form. Somehow there is all the world of difference between the drawings made by a painter and those made by a sculptor. The sculptor's hand may be working on the flat, but his imagination is all the time moving in a world of masses and solids. The drawings made by a sculptor are nearly always distinguishable as such, and all drawings by sculptors have something in common which is lacking in drawings made by painters. The difference cannot be analysed but it is always manifest. The drawing here shown of a panther (Fig. 37) is done with the utmost simplicity. Five lines only have been used for the body—that is to say, the pen has only been lifted from the paper four times. The rest is quick detail. Two minutes would have produced the sketch. Yet he has grasped the structure and solidity of the animal and given us a sculptural drawing. He did it so easily because he knew what was inside the lines that he drew—they were, as he said, lines drawn merely to define masses. Nothing could illustrate his own words more clearly.

Gaudier was years ahead of his time. Sculptors are now

ɔnce more beginning to take up things where he left them. He was an anachronism, like Van Gogh. But few will be found to interpret solid forms as he did, or with that swiftness of eye and sureness of touch which were so evidently his principal gifts.

ILLUSTRATIONS TO CHAPTER IV

On the porch of the pre-Conquest church at Langford, near Kelmscott, in Oxfordshire, is to be seen the finest Saxon sculpture in the south of England. It shows the Christ Crucified with the figure clothed in a full Byzantine gown with a girdle. The figure is rigidly cruciform and formal. Only in the drooping hands is there any touch of realism.

The head is missing and the figure is, perhaps, not in its original position, as the porch was reconstructed in the last century.

The Rood is more beautiful than the famous Rood in Romsey Abbey, but comparison is difficult as that at Romsey is undraped, save for a loin-cloth.

The Langford Rood was probably executed in the ninth century. A very similar ivory crucifix at Brunswick in Germany suggests a common Saxon style, itself directly derivative from Byzantium.

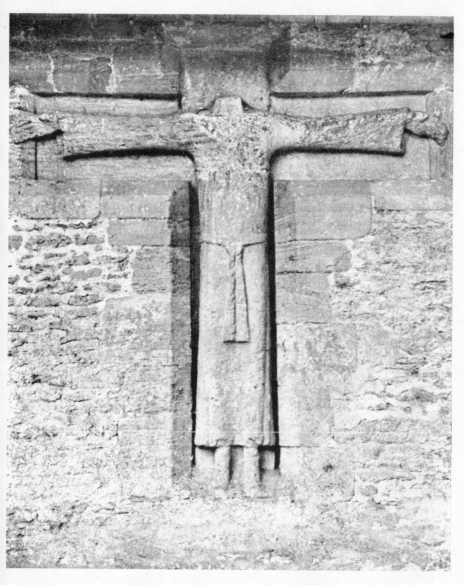

29. ANGLO-SAXON ROOD AT LANGFORD CHURCH,
OXFORDSHIRE

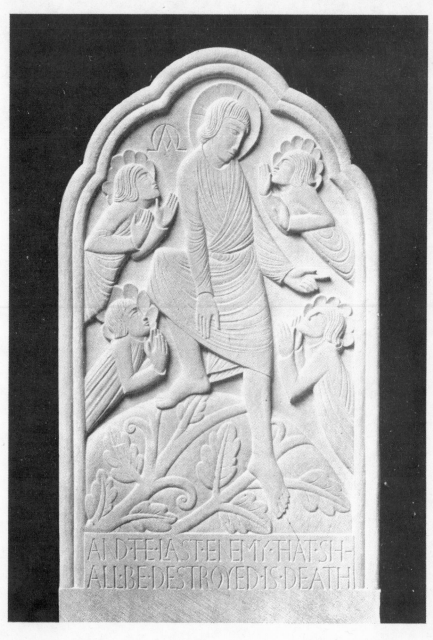

AND·THE·LAST·ENEMY·THAT·SH-ALL·BE·DESTROYED·IS·DEATH

30. STELE
*by Gill*

This lovely relief, in Hoptonwood stone, was exhibited at the Goupil Gallery in 1928. It is the most Anglo-Saxon of all Gill's works, both in its simplicity and in the heaviness of the figures. It is about three feet in height.

A very English study of an English type, with the hair treated formally. The head is life-size and in Bath stone. It was exhibited at the Goupil Gallery in 1928.

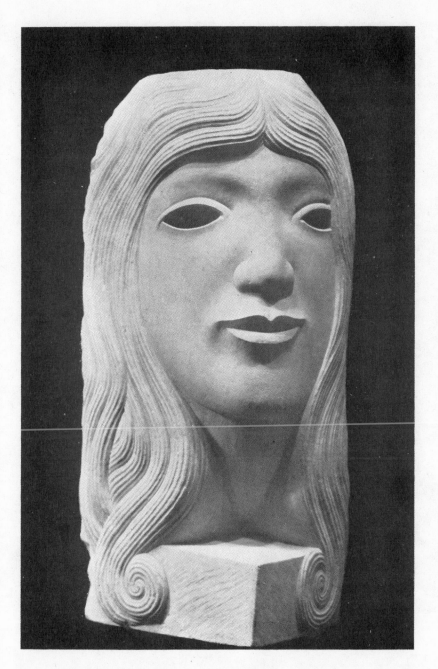

31. 'SUSAN'
*by Gill*

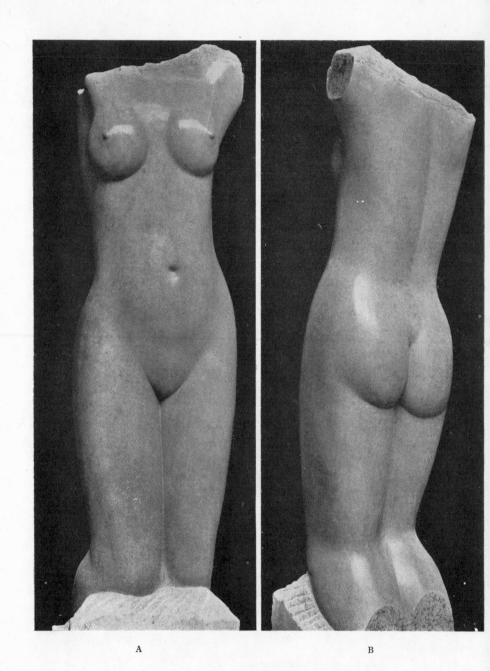

A                                    B

32. 'MANKIND'
*by Gill*

Gill's greatest masterpiece. The torso is more than life-size and of one piece of Hoptonwood stone.

The lovely surface which can be achieved on this material is clear in the photograph.

It was exhibited at the Goupil Gallery in 1928.

A head in limestone by Modigliani in the South Kensington Museum.

Modigliani was primarily a painter and had worked little in stone. He is seen here working under the influence of negro art.

The head is decorative and striking: it exhibits the extreme formalism of the human face.

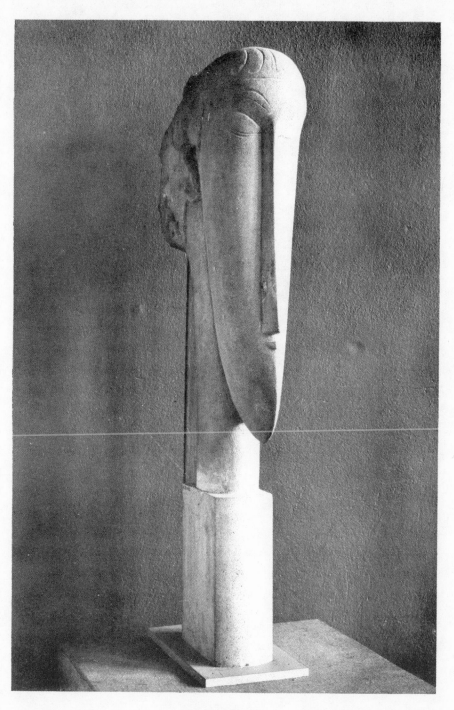

33. HEAD
*by Modigliani*

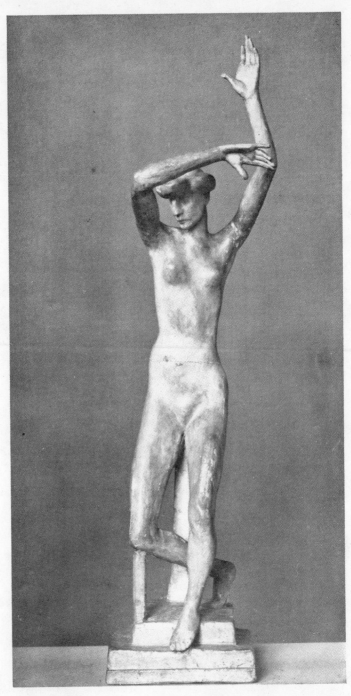

34. 'THE DANCER'
by *Gaudier-Brzeska*

This is the original by Gaudier-Brzeska of a bronze of which several copies exist. It is in the South Kensington Museum and is about a third life-size.

One of the bronzes is in the collection of Mr. G. Eumorfopoulos.

A small torso in white marble in the South Kensington Museum. It is the most perfectly finished of all the sculptor's works.

The slight swing of the shoulders and of the body on the hips gives it a life and mobility identical with those of the 'Dancer' (for which it is, perhaps, an early study).

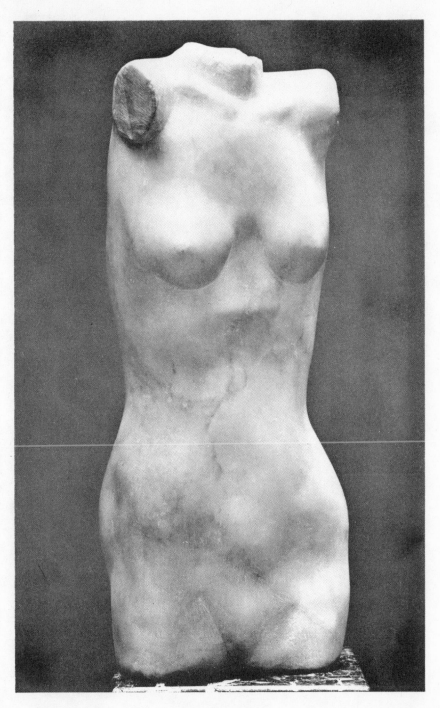

35. TORSO
*by Gaudier-Brzeska*

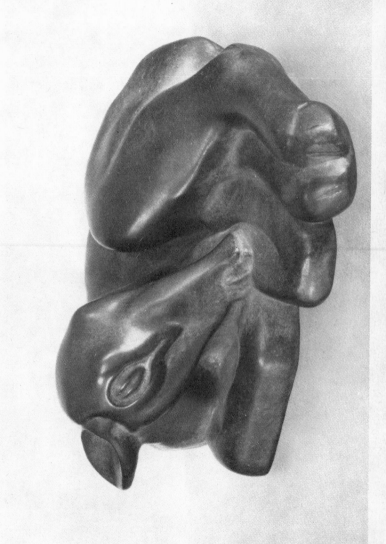

36. FAWN

by Gaudier-Brzeska

This example, in green bronze, of 'The Fawn' is now in the Leicester Galleries. Other copies exist.

The sculptor's feeling for shape and mass is very evident here.

He had carved another and equally charming 'Fawn' in stone (see E. Pound's *Memoir*, 1916, Pl. IX) showing the little creature with its head raised.

In this drawing (in the author's possession) all Gaudier's swift certainty of line is shown.

It is a hasty sketch done on scrap-paper, but it is the sketch of a sculptor.

37. PANTHER
*sketch by Gaudier-Brzeska*

## EPSTEIN AND DRAMATIC SCULPTURE

JACOB EPSTEIN has endured more than the usual share that falls to an original and inventive artist of the objurgations of the crowd. But his position is not unique in this respect. Barye, Rodin, Maillol, and others have received as much, though in the case of the two French sculptors abuse was not the only bludgeon used against them. Hostile intrigue also played its part in robbing them of livelihood and keeping them on the verge of destitution in their early years. Epstein belongs rather to an age when tolerance has thought it better to overwhelm an artist in garbage rather than drive him to the workhouse.

Original artists are by nature provocative and careless of opinion, but the tedious repetition of events seems to indicate that there is something more than mere coincidence in the way in which their works are assailed, and something more than their own provocativeness which is the cause of the public outcry that so often assails them. The complacency of routine public and social life defends its customary art with the savage insistency of a priest defending his flock. Nothing must assail the domestic perfection of an art that has been cut to fit a morality. Thus the coincidence that Rodin's 'L'Homme au nez cassé', Maillol's monument to Cézanne, Epstein's monument to Wilde, and his other to Hudson were greeted as ugly and immoral works that indicated the decadence of life and manners in their respective periods, is no longer an evident coincidence.

It is a normal reaction of Society upon Art, as normal as the views of Aristophanes upon Euripides or, more pathetically, those of Charles Dickens upon the pre-Raphaelites. The pathos of Sir John Collier describing Epstein's 'Rima' as 'a bestial figure, horribly misshapen with the face and head of a microcephalous idiot' and pleading for a return to pre-Raphaelite ideals and methods is emphasized when we read that the 'Christ in the house of his parents' by Sir John Millais was greeted in approximately the same terms. It was described by a contemporary critic as a picture from which 'we recoil with loathing and disgust. There are many to whom his work will seem a pictorial blasphemy.' Dickens in *Household Words* (a journal whose very title emphasizes the domestic character of some art-criticism) describes the picture as follows:

'In the foreground is a hideous, wry-necked, blubbering red-haired boy in a nightgown, who appears to have received a poke in the hand from the stick of another boy with whom he had been playing in an adjacent gutter, and to be holding it up for the contemplation of a kneeling woman, so horrible in her ugliness that (supposing it were possible for a human creature to exist for a moment with that dislocated throat) she would stand out from the rest of the company as a monster in the lowest ginshop in England.'

Later Whistler repeats for us the same weary old story of provocation and defence *ad nauseam*. In fact the attitude of public to artist is a dull and unprofitable repetition. The trouble is that so few recognize the repetition. Art is still supposed to have absolute standards, and those who execrate Epstein or Rodin or Barye or whoever the victim of the

moment may be, never seem to realize that they are as simple and inevitable a product of a Social Law as is the musk of the musk-rat or the ink of the squid of a Natural Law.

To estimate the importance of Epstein we must forget for a moment that we are squids or musk-rats defending our heritage and our lives against insidious attack: we must just pause to think what exactly the artist was trying to do, whether he has succeeded in doing it, and, finally, whether his aim and intention was both artistic and legitimate. Nothing else matters greatly.

Now the most obvious criticism of Epstein is that he is a man of many styles who has fallen under many influences. Maya and Aztec art, modern 'inorganic' tendencies, Rodin and the *malaise* school, and many another mannerism or style has guided his hand and absorbed his mind.

This eclectic searching seems due to the fact that he has an intensely personal style and too personal an outlook. Wherever his taste roams it always seems to hit on the same type of thing. From Maya, or Aztec, or Negro art, Epstein extracts what is most Epsteinian in character. From archaic Greek or from Rodinesque naturalism he takes what is most like his own ideals. He cannot get away from himself, and what is himself is not either wide enough in outlook or deep enough in significance at present to make him into a great artist. He is in origin one of an oppressed race, and his most personal expression of feeling is in sympathy with the grief and agony of oppression. His maidens are tragic and deeply wrought by emotion. His men are too often figures that cringe and grieve. But this manner he achieves

to perfection just because it is his most personal and most deeply felt style. The bust of 'Old Pinager' in the Aberdeen Art Gallery shows a bent and beaten old man, calm and peaceful but broken in spirit. His 'Weeping Woman' in the City Art Gallery at Leicester is the feminine counterpart. He seldom achieves calm beauty with success, but 'Nan' (Fig. 38) in the Tate Gallery and the portrait of Mrs. Epstein can rank as quite perfect examples of the pure and almost unemotional style. The same style combined with the qualities of 'Old Pinager' make 'The Visitation' in the Tate Gallery perhaps his finest work (Fig. 39). But there are reasons of technique also which place this work almost first among his achievements. Normally he has little sense of mass and line. He is in fact almost the antithesis in this of Gaudier. He rarely creates more than a head and shoulders because he is interested more in features and expression than in shape and mass and composition. But for once this gaunt and graceful figure of a young girl has achieved all that the eye could want. It is balanced; it is arranged with perfect symmetry; and it shows a regard for the compositional value of drapery and vertical lines that show what he is capable of when he considers the human body as a whole. The hair too is made to play a proper part in the balance of the head and shoulders, and the hands and forearms help the otherwise abrupt transition from the vertical folds of the skirt to the horizontal folds of the bodice in a way which has seldom been consciously done since the early fifth century B.C. in Greece. This statue too has the immense advantage of not being spoilt with a chemical patina. The bronze is almost untreated. The sur-

face of the face, too, is smooth and finely finished, a virtue which few of Epstein's works can boast. He has that inevitable tendency to a mud-pie finish which was Rodin's chief foible.

In many ways he is a true pupil of Rodin. Though he did not work under him he learned much from him. Chiefly he seems to have been impressed with the theory that underlies most of Rodin's work, that every statue must express an emotion, intellectual or physical. He only escaped from this tyranny for a brief period in 1913 and 1914 when he fell under the influence of the 'Vorticist' group. To this time belongs his 'Venus' in white marble and his 'Rock Drill' in polished bronze. The latter shows how completely he could, if he liked, get away from tradition and academicism and indulge in real experiment. The 'Rock Drill' is a masterly piece of suggestion. It shows a figure partly animate, partly mechanic, with a suggestion of brain and power that should belong to a Martian or a Robot. His 'Venus' is a delicate design of a human figure that at no point approaches realism. But here Epstein's experiments cease. He has sided definitely with emotional sculpture and abandoned stone for bronze. In so doing he has become a modeller rather than a sculptor. He thinks more in terms of building up in soft clay than in terms of revealing the core of a crude block of intractable material. I cannot but agree with Roger Fry's remarks : 'Is he a master of sculpture ?' says that critic, 'alas, I am bound to say no. If I examine my own sensations and emotions I am bound to confess that they seem to be of quite a different nature when I look at good sculpture from those I feel in front of

Mr. Epstein's bronzes. There is an undoubted pleasure in seeing any work accomplished with such confidence and assurance, such certainty and precision of touch: there is a powerful stimulus in the presence of such vividly dramatised personalities but the peculiar emotions which great sculpture gives seem to me quite different. . . . These busts are for me brilliant but rather crude representations in the round. If these are sculpture then I want another word for what M. Maillol and Mr. Dobson practise, let alone Luca della Robbia and the Sumerians.'[1]

In a word Epstein finds his own personality too overwhelming and the nature of stone too difficult or unsuitable. His early work on the façade of the British Medical Association building in the Strand, which he achieved in 1908, seemed to mark him out as a very great sculptor. The figures there are simple, unpictorial, and impressive. They have all the qualities of sculpture. But his work in stone was not to be continued. His ambition lay in a different world, that of the modeller. His relief in Hyde Park called 'Rima' seems hardly from the hand that carved the Strand statues or the 'Venus'. The latter seem mature, the 'Rima' the work of an inexperienced youth. So great is the loss of style and technique to a sculptor who abandons stone.

But, unlike Gill, Epstein thinks in the round. He has no liking for relief and little success at it, as 'Rima' shows. He thinks in solids but, for some reason which I cannot divine, he fails to establish the various planes and masses in those solids. That is why he avoids whole figures, with

[1] *New Statesman*, 26 Jan. 1924, p. 451.

the notable exception of 'The Visitation'. Not that he is incompetent to detect the structure of the human figure and the designs that can be derived from it, or the masses that compose it: but he is not interested in such considerations. The beauty of design as such, or of the designs that can be discovered in the human form, leave him cold. His figure called 'Christ' was hardly a figure at all because he had done virtually no work on the body. It was an experiment in emotion and a most unsuccessful one at that. His work has been generally described as 'Dramatic sculpture' and that is a title which indicates a nearly outworn tradition. Like Rodin he has attempted to make sculpture do what it cannot often be expected to do. The aim of the sculptor should be simply the beauty of form, not the expression of the dramatic aspects of life and its emotions and experiences. Such things may occur as the work is achieved but they should hardly be the chief aim of the artist.

Unlike Dobson and some of the younger artists Epstein seems to have fixed his style definitely and finally. His experimental stage belongs to the remote past and he will bow to no new influence. The hopeful years of 1913 and 1914 are gone.

But as a portrait maker of vivid personalities (that not infrequently resemble his own) he is superb. His 'Admiral Fisher', 'Joseph Conrad', and 'Jacob Kramer' remind one of portraits of the Medicis in their violence and their vividness. But simple beauty is not his aim or his achievement. His theories are too complicated and, in some respects, too old-fashioned.

This bust, in the Tate Gallery, shows Epstein at his least affected. It is finely finished and dignified.

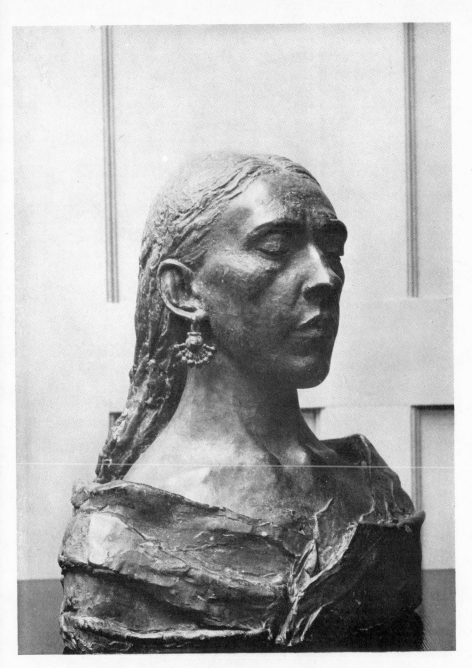

38. 'NAN'
*by Epstein*

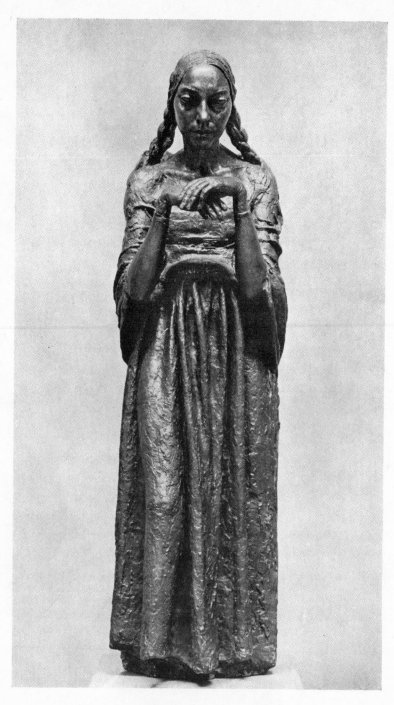

39. 'THE VISITATION'
*by Epstein*

## DESCRIPTION OF FIG. 39

Here Epstein shows qualities that he seldom expresses in his other works. This life-size figure is graceful and exhibits a deep sense of design and balance.

It is in the Tate Gallery.